Canaletto

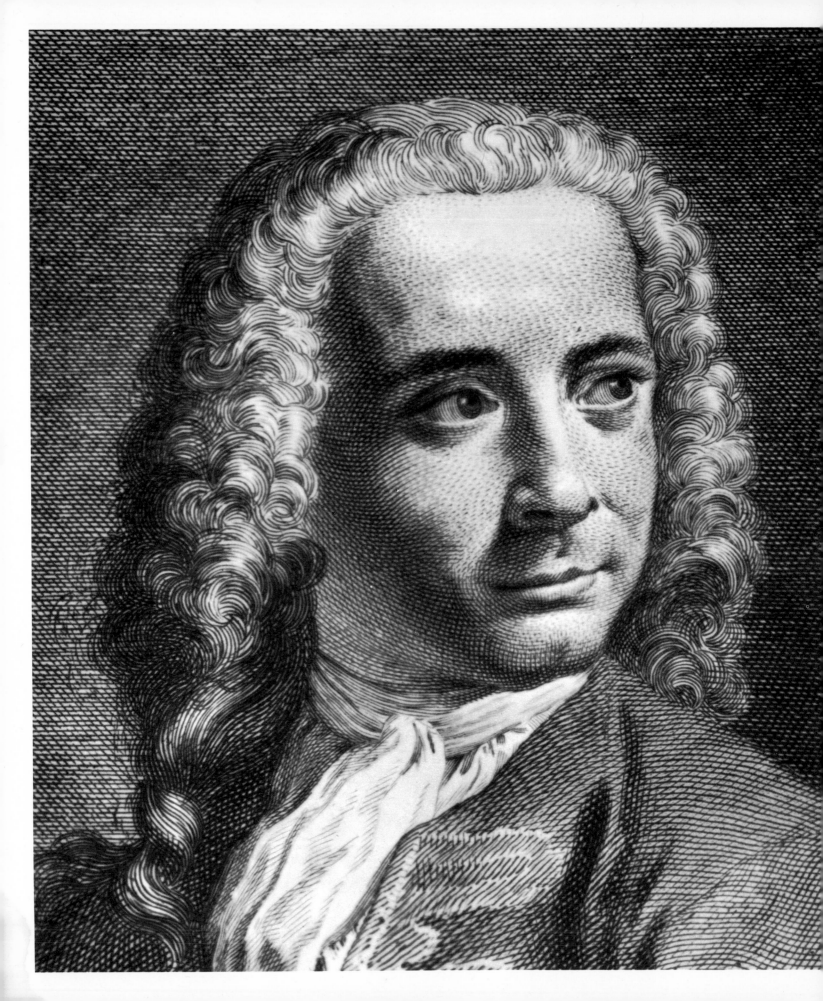

Adrian Eeles

Canaletto

The Colour Library of Art
Paul Hamlyn
London · New York · Sydney · Toronto

Acknowledgments

The following works are reproduced by Gracious Permission of Her Majesty the Queen: (Plates 4, 32, 49, Figures 4, 6, 10). The other works in this volume are reproduced by kind permission of the following collections, galleries and museums to which they belong: Senator Albertini Collection, Rome (Plate 6); Ashmolean Museum, Oxford (Plate 29); His Grace the Duke of Beaufort, Badminton, Gloucestershire (Plate 41); His Grace the Duke of Bedford and the Trustees of the Bedford Settled Estates, Woburn Abbey, Buckinghamshire (Plates 5, 20, 26, 27); Trustees of the British Museum, London (Figures 1, 3, 7, 8, 9); The Rt Hon. Lord Brownlow, Grantham (Plates 25, 30); His Grace the Duke of Buccleuch and Queensberry, Selkirk (Plates 36, 37); The Governors of Dulwich College, London (Plates 21, 39); Galleria dell'Accademia, Venice (Plate 46); Trustees of the Goodwood Collection, Chichester (Plates 7, 8, 31); Kunsthalle, Hamburg (Figure 11); The Rt Hon. The Earl of Malmesbury, Basingstoke (Plate 38); Mr and Mrs Paul Mellon Collection, Washington D. C., (Plates 34, 35); Museum of Fine Arts, Boston (Plate 22); Museum of Fine Arts, Boston. Gift of Miss Caroline Louise Williams French (Plates 9, 10); Museum of Fine Arts, Montreal (Plate 3); Trustees of the National Gallery, London (Plates 11, 12, 13, 16, 17, 23, 24, 47, 48); National Gallery of Art, Washington D. C. Gift of Mr Paul Mellon. On loan to American Embassy, London (Plates 43, 44); His Grace the Duke of Norfolk, Arundel, Sussex (Plate 45); His Grace the Duke of Northumberland, Alnwick, Northumberland (Plates 33, 42); Mrs Howard Pillow, Montreal (Plates 14, 15); On loan to Staatliche Museen, Gemaldegalerie, Berlin Dahlem (Plate 28); Staatliche Museen, Kupferstichkabinett, Berlin Dahlem (Figure 5); Thyssen Bornemisza Collection, Lugano (Plates 1, 2, 18, 19); The Rt Hon. The Earl of Warwick, Warwick Castle (Plate 40).

The following photographs were supplied by Thos. Agnew and Sons Ltd, London (Plate 42); Derek Balmer, Bristol (Plate 41); Brompton Studio, London (Plates 23, 24, 47, 48); Cameraphoto, Venice (Plate 46); Foto Cine Brunel, Lugano (Plates 1, 2, 18, 19); Michael Holford, London (Plates 5, 7, 8, 20, 26, 27, 31, 43, 44, 45); John Mackay, Grantham (Plates 25, 30); Reilly and Constantine, Birmingham (Plate 40); F. Rigamonti, Rome (Plate 6); Tom Scott, Edinburgh (Plates 36, 37); Sotheby & Co, London (Figure 2); Turners Photography, Newcastle upon Tyne (Plate 33).

First published 1967
Reprinted 1969

Published by the Hamlyn Publishing Group Limited
London · New York · Sydney · Toronto
Hamlyn House, The Centre, Feltham, Middlesex
© Paul Hamlyn 1967
Printed in Italy by Officine Grafiche Arnoldo Mondadori, Verona

Contents

Introduction

Giovanni Antonio Canal was born in Venice on October 18th 1697. His parents belonged to a respectable and well-defined class of Venetian society, and there are documents which show that the family was in possession of some property.

Bernardo Canal, the father, was a scene-painter. Theatrical sets were at that time complicated and highy fanciful: a typical backdrop would have a soaring perspective of arches, and a near-impossible combination of architectural details. The Bibiena family (from Rome) was particularly notable for this kind of fantasy and influenced theatrical design all over Italy (figure 2). Any artist might find such scene-painting an avid or frivolous exercise, but it would at least provide a worthwhile lesson in the problems of perspective. Antonio Canal therefore began his artistic career by assisting his father in the theatre, and the diminutive name Canaletto seems to have been adopted fairly early in order to distinguish the son from father.

In 1719, they both travelled to Rome where they are known to have made sets for two operas by Scarlatti (*Tito Sempronico Gracco* and *Turno Aricino*) which were performed during the carnival of 1720. Canaletto was still working in the theatre, but he was anxious to use his talents in other directions. Contemporary writers, Zanetti for example, record that he was painting landscapes and sketching the ruins of Rome, but no paintings of this period are known. It is not even certain that the series of Roman drawings usually attributed to him, now in the British Museum and at Darmstadt, are in fact the work of his hand. If the attribution is correct, they indicate that Canaletto acquired early experience in topographical draughtsmanship. His later, highly accomplished views of Venice would seem to point to this and it seems probable that the Roman sketches provided him with subject material which he was to use some twenty years later.

Canaletto was probably back in Venice by 1720, since in the register of the Brotherhood of Painters, the *Pittori nella Fraglia nell'anno 1687*, appears the entry: 'Canal, Antonio, 1720'. Certainly he had returned by 1722, when his name appears together with other artists involved in a project supervised by Owen McSwiney. Several years earlier McSwiney had left England following bankruptcy while manager of the Queen's Theatre in London. He travelled in France and Italy, arranging for performances of Italian operas in London and he also acted as artistic agent to the Earl of March (later Duke of Richmond). The commission in which Canaletto was involved was to be a series of paintings, each depicting the tomb of a notable Englishman in a landscape and/or architectural setting. Twenty-four paintings were eventually executed, of which Canaletto collaborated in two. He apparently stopped working for McSwiney after a short time, presumably in order to attend to the demands of other patrons. For example, the four views of Venice, formerly in the Liechtenstein Collection, must have been completed not later than 1723 because the pavement of the Piazza San Marco was re-laid in that year and one of the views shows the old brick paving that was replaced (see note to plate 1).

Canaletto's career as a painter of views had begun. In 1725 he was commissioned to provide two pairs of paintings for Stefano Conti, a merchant from Lucca. These paintings (now in the Pillow Collection, Montreal) are very well documented. Each pair has a memorandum, signed and dated by the artist, giving a description of each canvas, stating the price and acknowledging receipt of the payment. The prices are high, and suggest that Canaletto already had plenty of work and had achieved a certain recognition. Various other letters of this time, in particular those from McSwiney to the Duke of Richmond, indicate that Canaletto was not an easy person to deal with. For example, on

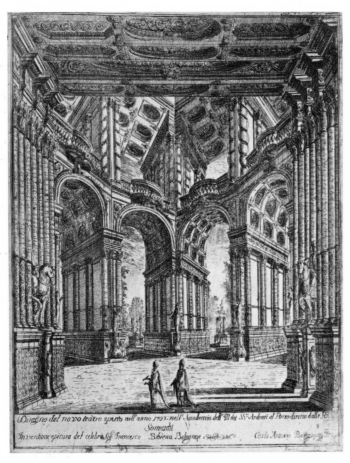

2 Carlo Antonio Buffagnoti. 'Design for a Stage Set'. Etching after Ferdinando Bibiena

November 28th 1727, McSwiney wrote to the Duke:

The fellow is whimsical and varys his prices every day: and he that has a mind to have any of his work must not seem too fond of it for he'l be ye worse treated for it, both in the price and the painting too. He has more work than he can doe, in any reasonable time, and well: but by the assistance of a particular friend, of his, I get once in two months a piece sketched out and a little time after finished, by force of bribery.

See Finberg, *Walpole Society* IX 1920-21

McSwiney may have exaggerated, but it is clear that Canaletto, having won success with such ease and rapidity, was both temperamental and expensive. On the other hand, among other reasons given for not completing a painting were that he had run out of good pigments and was awaiting new supplies, and that he had to work from nature (that is, not from preparatory drawings). Both these reasons are a credit to him.

The letter quoted above concerns four paintings on copper commissioned by McSwiney for the Duke of Richmond (see plate 7), of which two were sent late in 1727. Paintings on copper by Canaletto are very rare—almost all his paintings were done on canvas. In these early years Canaletto was painting, with a fairly loose hand, in cool tones over a dark red ground. The influence of Luca Carlevaris, his predecessor as a view painter, is clearly seen. Figures tend to be large and posed, often their scarlet or purple robes providing the prominent highlight. In the late 1720s and early 1730s Canaletto changed his style, abandoning large figures in the foreground. Colours are warmer and brighter; the delineation, both of figures and architecture, is more precise, and the result is a more literal, but less atmospheric view. Some of his best works are of this middle period, for example, *The Doge visiting the Church of San Rocco* and *The Stonemason's Yard* (plates 11 and 16). Canaletto was never at

a loss for subject matter. His patrons were nearly all foreigners: young Englishmen visiting Venice on the Grand Tour, ambassadors, merchants, foreign princes. For them Canaletto could provide views of the well-known squares, canals and churches; also depictions of the regattas, receptions and ceremonial processions. No other city has ever had such extensive pictorial documentation from one artist.

One of his best patrons was Joseph Smith, an English merchant resident in Venice. He was a book collector and considerable patron of Venetian artists, acting in the double capacity of a collector in his own right and as an agent for other collectors. A further account of his life can be found on page 21. Smith's personal collection of works by Canaletto, including fifty paintings and nearly one hundred and fifty drawings, was eventually sold to King George III and is now in the Royal Collection at Windsor. It contains representative examples of all Canaletto's work between the late 1720s and 1746, when the artist left for England, and is undoubtedly the best *corpus* of Canaletto's work in existence.

Apart from Canaletto's relations with Smith, little is known about his activities in the 1730s. Clearly he had enough commissions to keep him busy and very probably had pupils in his studio to assist him. These commissions included twenty-two views for the Duke of Bedford and twenty-one for Sir Robert Hervey, seventeen for the Earl of Carlisle. Many of the views produced at this time were engraved by the architect Antonio Visentini, and published for sale in 1735.

The outbreak of the War of the Austrian Succession in 1741 seriously curtailed travel in Europe. The flow of foreign visitors to Venice diminished and Canaletto found himself without patrons. At about this time he turned his attention to other views taken from the Venetian lagoon and from the towns along the river Brenta. He also painted for Smith a series of five views of Rome (now in the Royal Collection,

Windsor), which were almost certainly based on his earlier drawings and other artists' engravings rather than the result of a second visit to Rome. Smith also commissioned a group of 'over-doors', obviously intended to be part of a decorative scheme. They represent well-known monuments and buildings re-grouped in imaginary settings. These may be regarded as Canaletto's first departure from the strictly topographical, the first of the so-called *capriccii*. There are similar compositions in the form of pen-and-ink and wash drawings. These, unlike the multitude of preparatory sketches produced by Canaletto, were pictures in their own right—carefully composed and meticulously executed.

At this time Canaletto made a series of etchings (figures 7, 8 and 9), again at the instigation of Smith. Etching is a difficult medium, and it is a measure of Canaletto's genius that, apparently without previous experience, he was able to produce thirty-two plates of the highest quality. Some of them are actual views and others imaginary (*vedute ideate*) and in each case his sureness of touch and the linear felicity brings off a small masterpiece. There is a lyricism, indeed a depth of feeling, of which, up till now, one would have thought Canaletto incapable. Had not the English patrons disappeared, it is unlikely that Canaletto would have had time to spare for diversifying his talents.

But every artist needs commissions. It was no doubt the promise of work that induced Canaletto to leave Venice in 1746 and to travel to London. With an introductory letter from Joseph Smith, British Consul since 1744, to McSwiney, Canaletto obtained a commission for two views of the river Thames from the Duke of Richmond (plate 31). In 1747 he painted for Sir Hugh Smithson (later the Duke of Northumberland) *London seen through an Arch of Westminster Bridge* (plate 33), *Westminster Bridge Under Construction*, and *Windsor Castle*. Also at this time he produced *The Thames and Westminster on Lord Mayor's Day* (plate 34). In 1749 he painted

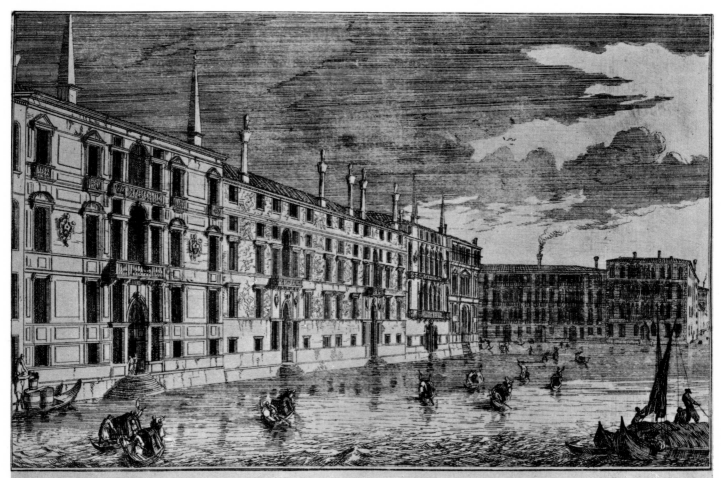

PALAZZI MOCENIGI A S. SAMVELE
Architettura di Andrea Palladio

Luca Carlevarijs del: et inc:

3 Luca Carlevaris. 'A View of the Grand Canal'

Badminton (plate 41) for the Duke of Beaufort, and it was probably on the same journey out of London that he visited Warwick Castle (plate 40).

Canaletto, however, was a disappointment to the English. George Vertue wrote: 'on the whole of him something is obscure or strange. He does not produce works so well done as those of Venice or other parts of Italy which are in Collections here.' He goes on to say that his handling of figures, water, and sky are not as excellent as formerly, that he is shy of being seen at work and that for these reasons he is suspected of being a fraud, and not the real Canaletto at all.

There are several explanations for Canaletto's failure to please the English. In the first place he was now nearing fifty years of age, and therefore unwilling or unable to adapt himself to new surroundings. Although his Thames views are fine and well executed, they are Venetian in character. Little attempt is made to portray the colder north European light or the texture of buildings made with English brick and stone. A bland Venetian sunlight pervades the scene, the sky is clear and the river water echoes the Basin of San Marco. It is the application of a matured technique to new surroundings, and lacks the 'picturesque' element which the English had come to expect from Canaletto. Moreover, the views of Badminton and Warwick were regarded with justification as definitely sub-standard. It should also be remembered that the English were best acquainted with works produced when Canaletto was in his prime. They were not familiar with his work of the late 1730s and early 1740s which, while remaining skilful, had become somewhat mechanical and derivative. Facility, and the high rate of production had given Canaletto's work a certain hardness and a sense of well-tried formulae being manipulated. It seemed as though imagination had become too great an effort for him.

Suggestions that Canaletto was an impostor were given added weight by the fact that his nephew, also a painter, adopted his name. Canaletto's sister Fiorenza had married Lorenzo Bellotto, and one of their children, Bernardo, had followed in the footsteps of his uncle. Little is known about the relations between uncle and nephew. Probably Bellotto was apprenticed in his uncle's studio, and certainly he modelled his style on Canaletto's. A year after the uncle left for London, the nephew left for Dresden in search of new patrons, and he was to stay in Germany and Poland for the rest of his life. It is certain that he deliberately adopted the name of Canaletto in order to benefit by his uncle's reputation, no doubt justifying it on account of the close family connection. It is easy to see, therefore, how the rumours arose that of the two Canalettos, the one resident in London was the wrong one.

In the year 1750 Canaletto returned for a short while to Venice. During that visit he is thought to have painted two views of *The Thames seen from the Terrace of Somerset House* (plate 32, detail). These had been commissioned by Consul Smith and would have been executed with the aid of preparatory drawings that Canaletto had made in London. By this time Canaletto had probably given up painting directly 'from nature' in favour of working in the studio with the aid of careful drawings.

By the summer of 1751, Canaletto was back in London. An advertisement appeared in *The Daily Advertiser* of July 31st which stated that 'Signior Canalleto' (sic) had painted a view of Chelsea College and Ranelagh House, and that the public were invited to inspect it at the artist's lodgings in Silver Street (now Beak Street, Soho). Another work apparently produced as a speculation was *Whitehall and the Privy Garden* (plate 36), one of the best pictures he painted while in England. The fact that these two pictures were produced as speculations, and that the artist began to make drawings for publishers of prints, seems to indicate that the

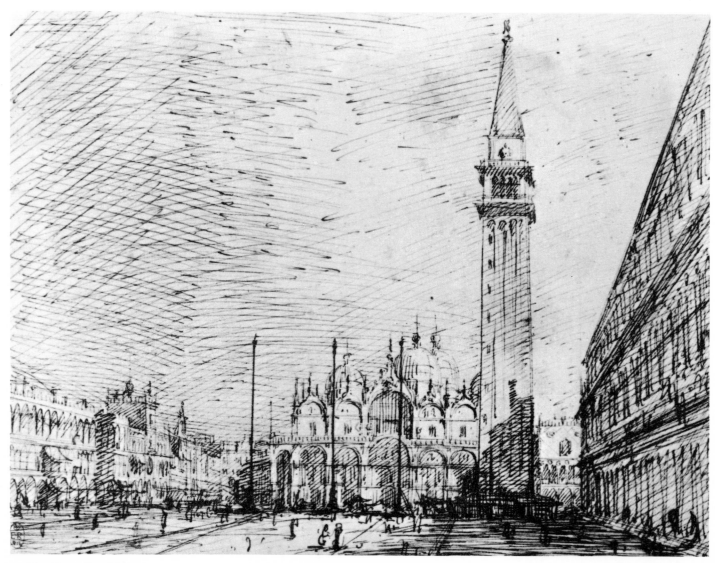

4 The Piazza San Marco

number of Canaletto's patrons was decreasing.

He returned to Venice again in 1753, then came back to England for another two or three years. Evidence for Canaletto being in England from 1754-1755 is provided by three pictures commissioned by Thomas Hollis, each of which had an inscription on the back such as the following: '*Fatto nel anno 1754 in Londra... ad istanza del signor cavaliere Hollis...*', made in the year 1754 in London... at the request of Mr. Hollis. Two of the inscriptions are dated 1754; the third, undated, is taken to be 1755. It is also probable that the series of capriccii commissioned by Baron King, an ancestor of the Earls of Lovelace (plates 43 and 44), were executed at this time. One of the series is dated 1754, and in them English and Italianate features are combined. One of Canaletto's most faithful patrons was the Duke of Northumberland who had commissioned views of Syon House and Alnwick Castle (plate 42). The latter, with which the duke is said to have been very pleased, is a strange product, attractive in a naive sort of way, but it demonstrates Canaletto's inability to come to terms with the English landscape. He was too old or too set in his ways to adapt himself.

In 1756, or thereabouts, Canaletto returned to Venice for good. The activities of his final years can be pieced together from the occasional document and from the evidence of his paintings. For example, we know that in 1759 he painted a capriccio which included Palladio's (unadopted) design for the Rialto Bridge and various buildings in Vicenza. This painting has not been identified with certainty. In 1760 two English travellers, John Hinchcliffe and John Crewe, saw an old man sketching in the Piazza San Marco. When Hinchcliffe, looking over his shoulder, ventured to say 'Canaletti', the artist replied '*mi conosce*' (you know me). It was, in fact, Canaletto himself and he invited them to call on him at his studio. Canaletto agreed to sell Hinchcliffe the finished drawing for which he was making

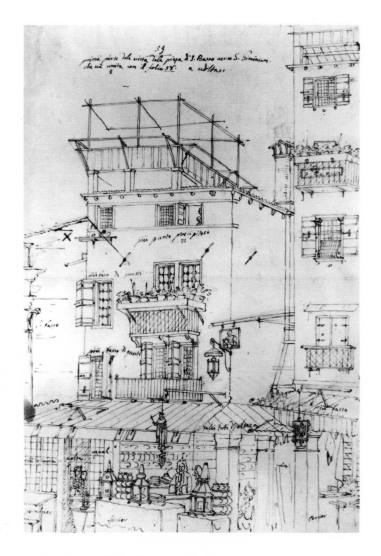

5 The Campo di San Basso: north side

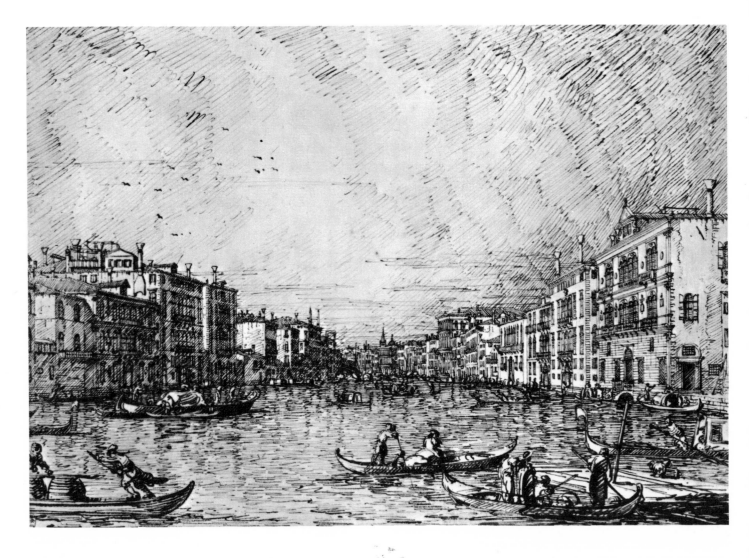

6　The Lower Reaches of the Grand Canal, facing the Rialto

the sketch and also presented him with the sketch itself.

During or before 1763 Canaletto produced a series of twelve drawings showing ceremonies or festivals in which the Doge took part. These drawings (of which two are still untraced) are highly elaborate works, of good quality, executed specifically to be copied by engravers. The complete set was engraved by Brustoloni and published between 1763 and 1766.

The other major work of the last years was the architectural capriccio, dated 1765, which Canaletto presented to the Accademia di Pittura e Scoltura after his election to that society in 1763. The Accademia, founded in 1756, was intended as a centre for the instruction of artists. Rather surprisingly Canaletto had not been elected when it was founded, possibly because of his absence abroad, and earlier in 1763 he had again failed to secure the required votes. However, at the second election in 1763 he was accepted. In the same year he became Prior of the Collegio dei Pittori, an office he had failed to achieve when put up as candidate in 1735. This would seem to indicate that the Venetians had been reluctant to acknowledge the talent of Canaletto. Compared with the esteem in which the figure painters and the landscape artists were held, painters of views were not highly regarded in Venice. Moreover, it should be remembered that none of Canaletto's patrons, or none of any consequence, was Venetian.

On April 19th, 1767, Canaletto died at the age of seventy-one. He was buried in one of the communal tombs of the Confraternity of the Santissimo Spirito of San Lio. He died intestate, and records made at the time concerning the settling of his estate, show that he had few possessions and very little money. This is a little surprising for someone who is supposed to have come back from England with his pockets filled with guineas. But Canaletto seems always to have been a secretive man and his private life remains a mystery.

We have seen that Canaletto was never much admired by the contemporary Venetians, who seem to have preferred figure painters like Longhi or allegorical painters like Piazzetta and the Tiepolos. Today, however, we tend to think of Canaletto above all in connection with eighteenth-century Venice. He cannot be regarded merely as a topographical delineator; his views of Venice are certainly accurate, except where he has deliberately falsified, and the perspective and detail are admirable. Yet there is more to them than verisimilitude. By careful choice of viewpoint, by close attention to the fall of light and shadow, and by apposite use of detail, Canaletto achieves a composition. For instance, in the *View of the Grand Canal* (plate 7), the bridge makes the focal point of the picture and the boats have been carefully positioned on the water. Again in the *Doge visiting the Church of San Rocco* (plate 11), a corner of the square filled with people has been transformed into an animated and coherent scene. For atmospheric quality one might look at an early canvas, the Grand Canal looking towards the Salute (plates 18 and 19); for compositional excellence the so-called *Stonemason's Yard* (plate 16) or the *View of Dolo* (plate 29).

All these paintings belong to the 1720s or early 1730s when Canaletto was in his prime. In later years, with long practice and fully perfected technique, Canaletto's work becomes somewhat mechanical. There is a certain rigidity of line and an almost slapdash treatment of the figures. We have already remarked how the large figures in the early canvases are reduced in size in the later works, sometimes becoming stereotyped blobs. His earlier practice of painting with moderate freedom over a red-brown ground, is abandoned in favour of a style of tighter and smoother brushwork overlaying a white ground, as for example, in *The Regatta on the Grand Canal* (plate 23).

This lack of spontaneity may partly have been the result of using mechanical aids. It is clear that a ruler has been

used for some of the straight lines, and possibly also compasses and dividers. It is also fairly certain that Canaletto occasionally used a *camera ottica* or *camera obscura*. This is a device for verifying perspective. Artists had been using various models since the early sixteenth century. The type probably used by Canaletto was a square wooden box with a lens mounted in one side. Inside the box was a mirror set at an angle, so that the image projected on it by the lens would be reflected upwards. The top of the box would be made of ground glass, on which the image reflected by the mirror would show up. It was then possible to trace the image (for example, a street perspective), on to paper. Dr. Terisio Pignatti has discovered just such a *camera ottica* in the Correr Museum, bearing the inscription 'A Canal' on the lid.

It is virtually impossible to say whether or not Canaletto employed assistants and if he did how much they were allowed to do. There is not even any proof that his nephew, Bellotto, worked in his studio.

In connection with Canaletto's working methods, something should be said of the drawings. Broadly speaking there are four categories: firstly, the diagrammatic drawings, for example figure 5, made on the spot, with notes written in to indicate the colours, the identity of the building, and other details. Clearly without these *aide-memoires* Canaletto could not have worked so accurately. Secondly, there are preparatory sketches, for example figure 6, which are a stage in the working-out of the composition. Thirdly, there are the drawings made for engravings, for instance the twelve drawings of ducal ceremonies, engraved by Brustoloni. Lastly, there are the drawings which, unconnected with any subsequent painting or engraving, are produced as works of art in their own right, for example figure 11 and plate 49. These are more finished products, executed with thought and a certain dash, particularly in the use of wash to enhance the pen-and-ink outlines.

More of this type appear to have been done in the 1740s when Canaletto found himself less occupied with commissions. It is also about this time that, released from the demands of patrons, Canaletto turned away from the topography of Venice. This is the time of the Roman views and of the imaginative compositions, for example his delightful etchings. Once again we can see Canaletto's virtuosity displayed, and, as it were, a renaissance of his talent.

However, on coming to England and being faced with the demands of clients, the well-tried formulae are applied again. This is not to deprecate the high quality of Canaletto's Thames views. The *View from Richmond House* (plate 31) and the *Arch of Westminster Bridge* (plate 33) are undeniably accomplished and the effect is dazzling. Maybe the English were expecting too much, but one understands their disappointment when faced with these excellent but stale products—especially when compared with the earlier Venetian views that they knew. But we must remember that the feeling of disappointment did not deter patrons from keeping Canaletto fully occupied in England for ten years. During that time he produced nearly forty views (London, Windsor, Badminton and others) and at least half-a-dozen capriccio paintings, not to mention innumerable drawings.

The production of capriccii indicates both a new interest for Canaletto and a new taste among collectors. For an artist who had perfected his techniques and who had by this time painted the same view several times over, an essay in fanciful juxtapositions would provide a new stimulus. In the pair of capriccii illustrated as plates 43 and 44, for example, we find an amusing combination of the English and the Italianate. Or in the *Capriccio with Palace and Clock Tower* (plate 45) we find a combination of architectural extravaganza and picturesque decay. Like the Venetian lagoon fantasies of Canaletto's contemporary, Guardi, these paintings had a growing popularity and it is not perhaps too

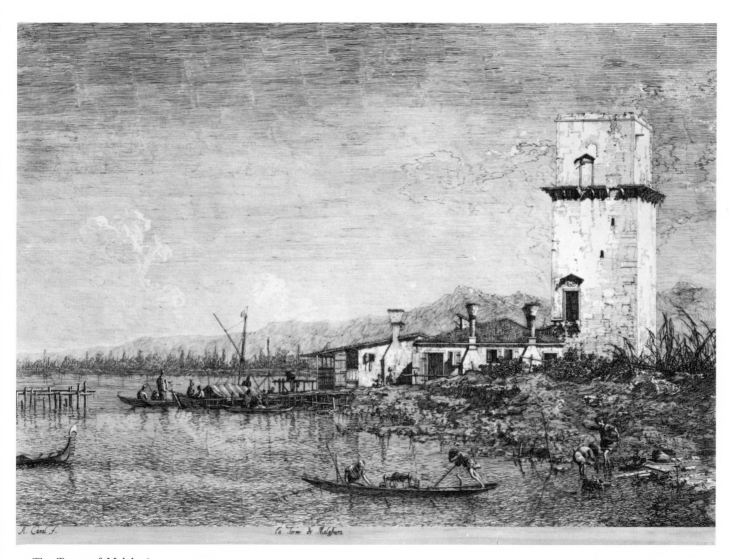

Ca Torre di Malghera

7 The Tower of Malgherà

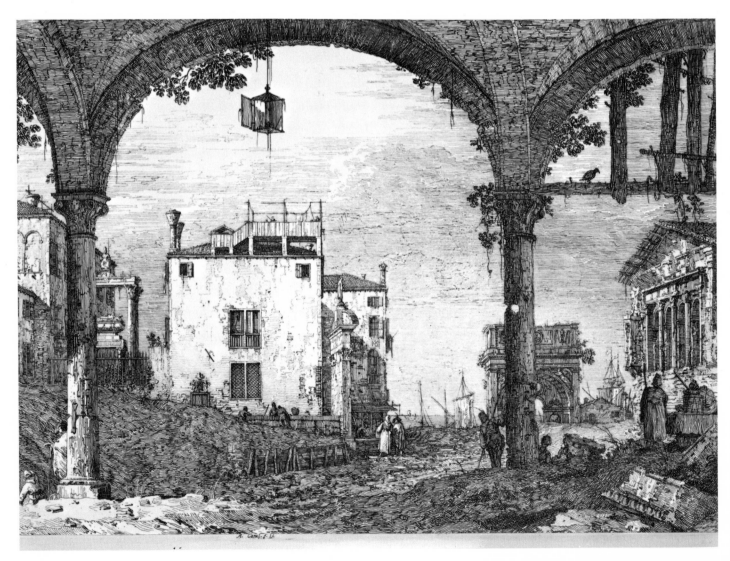

8 The Portico with a Lantern

18

far-fetched to regard this taste for capriccii as symptomatic of the emergence of romanticism, and to compare it with the growing English taste for the 'Gothick' in architecture.

As Canaletto grew older even his capriccii lose some of their spontaneity. The presentation painting for the Accademia, dated three years before his death, is certainly accomplished but it lacks vigour. Even so, the paintings and drawings of the last years show the mark of genius. Take for example the pair of *Views of the Piazza San Marco* (plates 47 and 48); the handling is calligraphic but they have something of the old magic. Canaletto's late style is often described as 'calligraphic' (Greek: *Kalligraphia*, beautiful handwriting). The word is used to denote a particular method of applying brush or pen-strokes, a conscious repetition of dots and twirls, the pattern of which makes up the composition. The *Capriccio with a Flight of Steps* (plate 49) is a good example of calligraphic style, particularly in the tree on the right side and the ornamentation of the loggia.

During the years of his prime, Canaletto transformed the approach to topographical painting. He had a decisive influence on Venetian painters like Francesco Guardi, Michele Marieschi, and of course Bellotto. In England he was imitated by Samuel Scott, and Scott's pupil, William Marlow. In general his influence on view painters is hard to gauge, but none would dispute that it was great. Not only had Canaletto made view painting respectable, but he had also shown that a simple view could be a superb work of art, capable of expressing great depth of feeling and of giving lasting delight.

JOSEPH SMITH AND CANALETTO

Joseph Smith was one of the greatest collectors of the eighteenth century. He was responsible for amassing an outstanding group of works by Canaletto (now in the Royal Collection at Windsor) and for this reason alone his life and character deserve a short notice.

Joseph Smith was born in about 1676. Nothing is known of his early years except that he was a scholar at Westminster School. Some time at the beginning of the eighteenth century he settled in Venice, was apprenticed to the Consul, Thomas Williams, and apparently earning his living as a merchant and banker. All through his life he had a keen interest in finance and it is clear that he was a successful businessman. In about 1710 he married a celebrated opera singer, Katherine Tofts, allegedly very rich, and allegedly liable to fits of madness which required her to be kept under permanent restraint.

Smith's first passion was book collecting. He was interested not only in collecting old books if they met with his fastidious standards, but also in contemporary book production in Venice. To this end he launched the publisher G. B. Pasquali, and gave constructive support to the production of fine books, many of them illustrated. In the years before 1730 he was also buying paintings by contemporary Venetian artists such as Rosalba Carriera, Sebastiano Ricci, Marco Ricci, and G. B. Piazzetta.

It is not known how or when he made his first contact with Canaletto, but it is thought to have been in about 1728. The first commission was for a set of six views in or near the Piazza San Marco which are fine examples of Canaletto's early style, and can be dated between 1726 and 1728. Then followed a series of fourteen views on the Grand Canal, executed about 1729-30. These were all engraved by Visentini at the instigation of Smith himself.

Smith not only commissioned works for his own collection, but also acted as agent for other patrons. We cannot be certain whether he was only an intermediary, or whether he bought canvases from the artist with a view to re-selling them for his own profit. He may well have acted in both capacities. What is certain is that Smith and Canaletto were closely associated for several years, to the advantage of both.

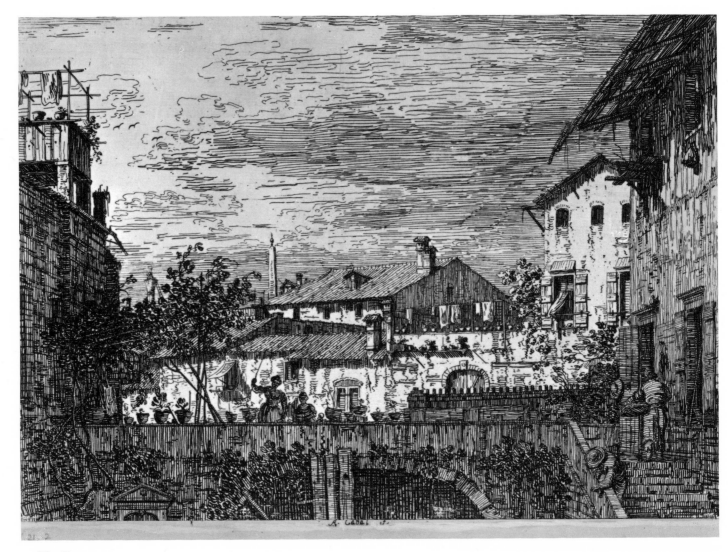

9 The Terrace

After 1740 when the number of Canaletto's commissions diminished, Smith filled the breach by commissioning the series of views of Rome, although it now seems unlikely that he and the painter visited Rome together. Also at this time Smith ordered the thirteen decorative over-doors. The series of etchings are also dedicated to him. Directly and indirectly, Smith had proved himself to be Canaletto's most assiduous patron. When the artist left Venice in 1746, Joseph Smith sent word to Owen McSwiney in London, asking him to help Canaletto to find employment. Indeed it might have been Smith who, having given substantial support to Canaletto in difficult years, suggested that a journey to England would be profitable.

In 1744 Smith was appointed Consul. By this time he was a well-known figure in Venetian society. His palace on the Grand Canal, housing a unique collection of books, gems, paintings and drawings, was open to any visitor sufficiently curious. He had many acquaintances and yet few people liked him. Contemporary diarists like Horace Walpole and Lady Mary Wortley Montague were consistently critical of him (resentment, perhaps that a tradesman should have such good taste?). It is known that Smith was very disappointed not to be made the Resident in 1752; however he wooed the new Resident's sister and married her in 1758. In 1760 he resigned the consulship, but resumed the post again in 1766 when his successor went bankrupt.

Meanwhile in 1756 there had been negotiations with the Prince of Wales (the future King George III) about the sale of Smith's library, but the exchanges had come to nothing because of the outbreak of the Seven Years War. However, in the early 1760s the matter was taken up again, and this time it was not only the library, but the entire collection that was in question. In July 1762, negotiations were completed and Smith signed a letter accepting the terms of sale, by which the King agreed to purchase the collection for £20,000.

By 1764 Smith had been paid in full, and he had the additional satisfaction of knowing that his collection was to remain intact.

A notable part of the collection sold to George III was the group of works by Canaletto, consisting of over fifty paintings and nearly one hundred and fifty drawings. It was, and remains to this day, the finest and most representative collection of this artist's work. One can appreciate Consul Smith's concern that the group should never be dispersed.

Smith died in 1770, aged over ninety. He was buried in the Protestant cemetery at San Nicolò al Lido. Sixteen years later his grave was sought out by Goethe, who wrote of it as follows:

'Not far from the beach lies the Cemetery for the English and, a little further on, that for the Jews, neither of whom are allowed to rest in consecrated ground. I found the graves of the good consul Smith and his first wife. To him I owe my copy of Palladio and I offered up a grateful prayer at his unconsecrated grave, which was half buried in the sand'.
Extract from Goethe, Italian Journey *(1786-1788). Translated by W. H. Auden and Elizabeth Mayer, London 1962.*

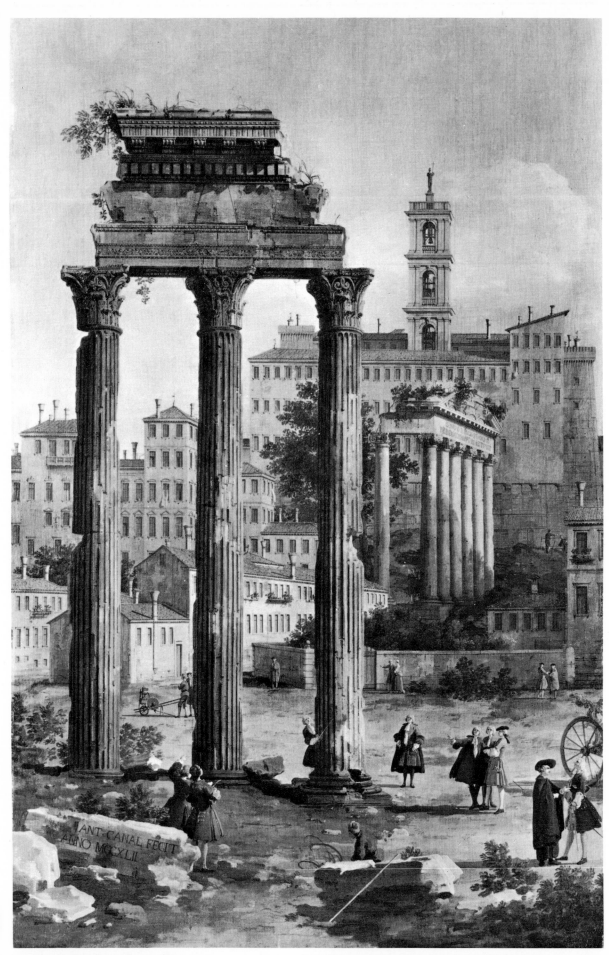

ANT·CANAL·FECIT
ANNO·MDCXLII

10 The Ruins of the Forum, Rome

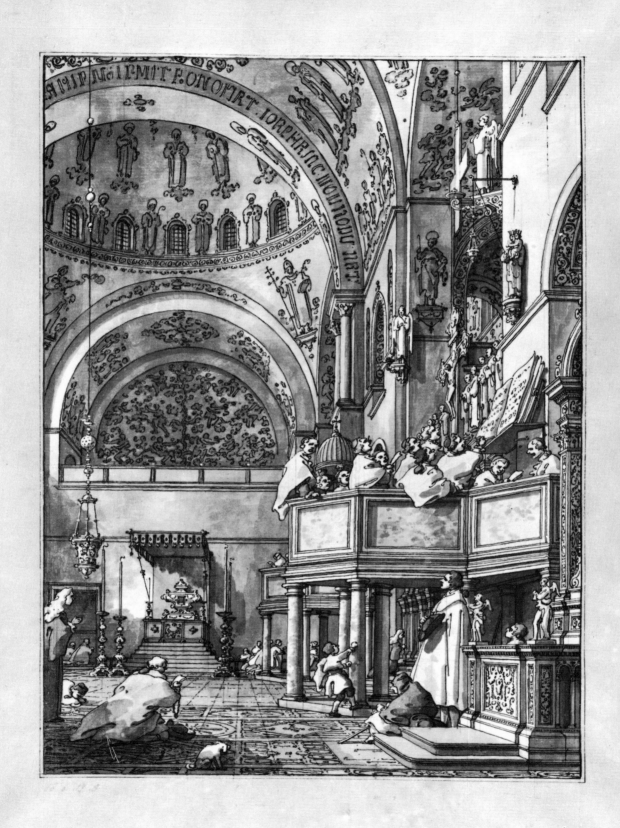

Io Zuane Antonio da Canal, Hò fatto il presente disegnio delli Musici che Canta nella Chiesa Ducal di S. Marco in Venezia in'età de Anni 68 Cenzza Ochiali, L'anno 1766.

Biographical outline

1697 Giovanni Antonio Canal born in Venice, October 28th and baptised at the church of San Lio.

From Giovanni Antonio and his brother, Cristoforo, help their
1716 father, Bernardo Canal, with scene painting for Venetian theatres.

1719 Accompanies his father to Rome, where sets for two Scarlatti operas are prepared. Also made sketches of Roman antiquities.

1720 Probable date of Canaletto's return to Venice. Recorded as a member of the *fraglia* (brotherhood) of Venetian painters.
Birth of Bernardo Bellotto, the son of Lorenzo Bellotto and Canaletto's sister Fiorenza.

1722 Canaletto's name appears with other Venetian artists in connection with two allegorical paintings commissioned by Owen McSwiney.

1723 The Piazza San Marco is repaved, thus giving a probable date for the completion of the four views of Venice (formerly in the Liechtenstein collection), one of which shows the old brick pavement of the Piazza.

1725 Completion of a pair of views of Venice commissioned by Stefano Conti.

1726 Another pair of Venetian views delivered to Stefano Conti.

1727 Owen McSwiney writes to the Duke of Richmond concerning four views of Venice painted on copper, two of which were about to be delivered.

1728 Approximate date of Joseph Smith's first dealings with Canaletto. The series of six views in or near the Piazza San Marco are executed.

1729- Probable time of execution of the set of fourteen views on
1730 the Grand Canal for Smith, who mentions them in a letter to Samuel Hill, and arranges for them to be engraved by Visentini.

1735 First publication of the series of fourteen views engraved by Visentini, entitled *Prospectus Magni Canalis Venetiarum...*

1740 Canaletto fully occupied painting views for the Duke of Bedford, Sir Robert Hervey and other patrons, many of them English. *The Stonemason's Yard* and *The Doge visiting the Church of San Rocco* probably painted by 1735.

1741 Outbreak of the War of the Austrian Succession, curtailing the movement of travellers. Canaletto consequently receives fewer commissions.

1742 Five views of Rome painted for Smith. Second publication of the Visentini views, with twenty-four additional plates.

1743 *View of the Colosseum* painted for Smith.

1744 Joseph Smith appointed Consul, thus dating the publi-

cation of Canaletto's series of etchings which are dedicated '*All'Illmo Signor Giuseppe Smith Console di S. M. Britanica...*' The etchings may have been executed at a slightly earlier date.

Date of the thirteen capriccii intended as over-doors, commissioned by Smith.

1746 Canaletto leaves Venice for England. His first commission is to paint two views of the Thames from Richmond House.

1747 Sir Hugh Smithson (later Duke of Northumberland) commissions *London seen through an Arch of Westminster Bridge, Westminster Bridge under Construction* and *Windsor Castle.*

1749 Two views of Badminton painted for the Duke of Beaufort. The views of Warwick Castle probably painted at the same time.

George Vertue in his notebooks echoes the general disappointment in Canaletto's work and mentions the rumour about Canaletto being an impostor.

1750 Canaletto returns to Venice. While there he probably paints the pair of views of the *Thames from the Terrace of Somerset House* for Smith.

1751 Canaletto back in London by the summer. He advertises his *View of Chelsea College and Ranelagh* in the *Daily Advertiser*. Probable date of execution of the *View of Whitehall and the Privy Garden*, also apparently painted as a speculation.

1752 Probable date of the *View of Alnwick Castle.*

1753 Canaletto pays another short visit to Venice.

1754 Canaletto back in England, painting views and capriccii for Thomas Hollis and various other patrons.

1756 Canaletto returns to Venice for good.

1760 The artist is seen sketching in the Piazza San Marco by two English travellers.

1763 In July, Smith agrees to terms for the sale of his collection to King George III.

Between now and 1766 the twelve scenes of ducal ceremonies, engraved by Brustoloni after drawings by Canaletto, are published.

Canaletto's election to the Accademia di Pittura e Scultura is defeated in favour of Zuccarelli, Gradizzi and Pavona; in September, however, he is elected. He is also elected Prior of the Collegio dei Pittori and a member of the Committee of Twelve responsible for administration.

1765 Date of the architectural capriccio painted for presentation upon his election to the Accademia.

1766 Date of the pen-and-ink and wash drawing, *The Interior of San Marco with Choristers*, inscribed by Canaletto to the effect that he had made it, aged sixty-eight, without spectacles.

1768 The Necrology of the Sanità records the death of Canaletto on April 19th. The funeral is '*con Capitolo*' (that is, with twelve priests, and candles) and he is buried in the communal tomb of the Confraternity of the Santissimo Spirito of San Lio.

SELECTED BOOKLIST

The following books are recommended for a more detailed study of Canaletto and his times.

A. de Vesme: *Le Peintre-Graveur Italien* Milan, 1906

H. F. Finberg: *Canaletto in England,* Walpole Society, London, IX (1920-21), 21; X (1921-22) Supplement

Rodolfo Palluchini & G. F. Guarnati: *Le acqueforti del Canaletto*, Venice, 1945

K. T. Parker: *Drawings of Antonio Canaletto in the Collection of His Majesty the King at Windsor Castle*, Oxford & London, 1948

F. J. B. Watson: *Canaletto*, London & New York (2nd edition), 1954

Vittorio Moschini: *Canaletto*, Milan, 1954

Michael Levey: *National Gallery Catalogues: The Eighteenth Century Italian Schools*, London, 1956

W. G. Constable: *Canaletto*, Oxford, 1962

Francis Haskell: *Patrons and Painters. A Study in the Relations between Italian Art and Society in the Age of the Baroque*, London, 1963

Notes on the illustrations

Figure 1 Frontispiece. Antonio Visentini. *Portrait of Canaletto* (detail). Engraving after G. B. Piazzetta.
This portrait appears side by side with a portrait of the engraver Visentini and forms the frontispiece to *Prospectus Magni Canalis Venetiarum*, the series of fourteen views of the Grand Canal engraved by Visentini after paintings by Canaletto, published in 1735.

Canaletto would have been aged thirty-eight at the time of this portrait. The 'monochrome' original by Piazzetta has not been found. It is the only known portrait of the artist, apart from an alleged self-portrait in oils (in the collection of the late Lord Fairhaven, Anglesey Abbey).

Figure 2 Carlo Antonio Buffagnotti. *Design for a Stage Set*. Etching after Ferdinando Bibiena. 14 × 10 in. (35.6 × 25.4 cm.).
This etching is from a series published with the title *Varie Opere di Prospettiva Inventate da Ferdinando Galli*. It dates from the early eighteenth century and is a good example of the type of theatrical design which was then favoured. Canaletto, when scene painting in his youth, would have come in contact with, if not copied, this extravagant style. It is understandable if theatrical work did not appeal to him, but at least it must have provided an early lesson in the use (and abuse) of perspective.

Figure 3 Luca Carlevaris. *A View of the Grand Canal*. Etching. 7¼ × 11½ in. (17 × 29 cm.).
From a book of etched views of Venice entitled *Le Fabriche e Vedute di Venetia* published in 1703. Although it is not at all certain that Canaletto was ever a pupil of Carlevaris, the influence of the latter is obvious. It is also of interest that Carlevaris' etchings of Venice are among the earliest instances of the production of views for their own sake; they were intended primarily for the tourists.

Figure 4 *The Piazza San Marco*. Pen-and-ink drawing. 7 × 9¼ in. (18 × 24.3 cm.). The Royal Collection, Windsor.
One of a series of six drawings which correspond very closely with the six paintings, formerly in the possession of Consul Smith, which date from 1726-28. Notice how swift and assured the pen-strokes are, particularly at the base of the Campanile and in the sky.

Figure 5 *The Campo di San Basso: north side*. Pen-and-ink over black chalk. 17 × 11½ in. (43.2 × 29.3 cm.). Staatliche Museen, Kupferstichkabinett, Berlin Dahlem.
A good example of one of Canaletto's many diagrammatic drawings, intended as a preliminary for a larger view in oils. The drawing has notes in the artist's hand, and, being part of a sequence of drawings, is numbered 59.

Figure 6 *The Lower Reaches of the Grand Canal, facing the Rialto*. Pen-and-ink. 10⅝ × 14⅞ in. (27 × 37.7 cm.). The Royal Collection, Windsor.
One of a series of views of the Grand Canal which Parker dates in the mid-1730s. The execution is highly accomplished, a careful but vigorous drawing.

Figure 7 *The Tower of Malgherà*. Etching, first state (of two). 11½ × 16⅝ in. (29.3 × 42.3 cm.).
The Tower of Malgherà, now destroyed, stood on the edge of the Venetian lagoon. Although this is not a *veduta ideata* it has the qualities of one. It pictures the stillness of a remote and watery outpost of the lagoon lying under the hot midday sun. Notice particularly how the artist has caught the effect of bright sunlight reflected on the peeling walls of the tower.

Figure 8 *The Portico with a Lantern*. Etching, second state (of three). 11¾ × 16½ in. (29.3 × 42.3 cm.).

One of the best plates in the series of thirty-two etchings by Canaletto, published in 1744 and dedicated to Consul Smith. The etchings were produced at a time when Canaletto was going through a difficult phase of his artistic career, when the flow of foreign patrons had diminished, and before the artist had decided to go to England in search of new commissions. The fact that the series was dedicated to Consul Smith would suggest that the etchings were produced at his instigation, possibly to help Canaletto out of difficult financial circumstances.

The etchings themselves are of extremely high quality and do not show any lack of inspiration. As the title records, they are views both actual and imaginary (*Vedute altre prese da i Luoghi altre ideate*). *The Portico with a Lantern* would be classed as a *veduta ideata*. Notice the outstanding effectiveness of the composition and the light though firm touch in every line. When one considers that Canaletto was not familiar with etching as a medium, one marvels at the degree of competence. The effect is dazzling and singularly atmospheric. Moreover this etching has no suspicion of mannered contrivance such as the later capriccio paintings and drawings betray.

Figure 9 *The Terrace*. Etching, first state (of two). 5½ × 8 in. (14 × 20 cm.).

From the series of thirty-two etched views (see note to figure 8). This is probably based on an actual group of buildings in or near Venice. It is a fine example of Canaletto's delight in detail and his complete mastery of it. The purity of line and the subtle gradations of black and white, which the medium of etching affords, have been exploited with amazing skill.

Figure 10 *The Ruins of the Forum, Rome*. Oil on canvas. 24 × 37½ in. (61 × 95 cm.). The Royal Collection, Windsor.

One of a group of six views of Rome painted for Consul Smith in 1742. In the foreground is the Temple of Castor and Pollux. Rising behind the Forum are the buildings of the Capitol.

Figure 11 *The Interior of San Marco*. Pen-and-ink and wash. 14⅛ × 10¾ in. (35.9 × 27.5 cm.). Kunsthalle, Hamburg.

A view towards the north transept with a choir singing in the musicians' gallery. Beneath the drawing is the following inscription in Canaletto's hand: *Io Zuane Antonio da Canal, Ho fatto il presente disegnio, delli Musici che canta nella Chiesa Ducal di S. Marco in Venezia in etta de-/Anni 68 Cenzza Ochiali, Lanno 1766*. Translated, this reads: 'I, Giovanni Antonio da Canal, have made this drawing of the musicians singing in the Ducal Church of San Marco, Venice, at the age of 68, without spectacles, in the year 1766.' Canaletto died two years later.

THE COLOUR PLATES

Plates 1 and 2 *The Piazza San Marco*, and detail. Oil on canvas. 56 × 84¾ in. (142 × 205 cm.). Thyssen Bornemisza Collection, Lugano.

One of a set of four paintings formerly in the Liechtenstein collection. Of Canaletto's many views of the Piazza San Marco, this must be one of the earliest. In the first place, the low tonal key and the rather loose handling of the paint (particularly noticeable on the figures), suggest an early date of execution. Secondly, and more conclusively, the Piazza is here unevenly paved with red brick. Since we know that a new marble pavement with geometric patterns was laid down by Andrea Tirali in 1723, it is fairly safe to assume that this painting was done in 1723 at the latest, and it may

quite possibly have been done a year or two before that.

Plate 3 *San Marco: the interior*. Oil on canvas. 16½ × 11½ in. (42 × 29 cm.). Museum of Fine Arts, Montreal.
Probably painted in 1755-56 after Canaletto's return from England. A view of the interior of the basilica, looking east towards the chancel screen. It clearly shows the architectural construction of the church, of which the salient features are a shell built in the form of a Greek cross with four domes surmounting the crossing, the two transepts and the nave. This is in the Byzantine tradition, as are also the mosaics, which date from the twelfth and thirteenth centuries.

The banner hanging from the central dome bears the inscription 'Verona Fidelis' and the coats of arms decorating the nave are those of various patrician families of Venice.

The detail in this painting is masterful and well worth scrutiny.

Plate 4 *The Piazzetta: looking north*. Oil on canvas. 67 × 51 in. (170.2 × 129.5 cm.). The Royal Collection, Windsor.
One of the group of six views painted 1726-28, formerly in the possession of Consul Smith.

The Piazzetta is an extension of the Piazza San Marco, leading down to the Molo (the water's edge). In this view the spectator is standing with his back to the water and looking up the Piazzetta towards the main square. Thus the façade of the basilica is on the right, and the Campanile on the left side, while the Torre dell'Orologio is straight ahead. Also visible is the Library, in front of the Campanile, and on the extreme right, part of Saint Theodoric's column.

The painting may be classified as an early work on account of the free handling of the brushwork and the way in which large and distinctive figures have been brought into the composition. Notice in particular the man with red robes and a white wig, who is probably a state official. The Vene-

tian Republic had a very carefully defined social structure, and the clothes that a citizen wore could be an accurate guide to status and importance in the community.

Plate 5 *The Molo and Piazzetta seen from the Bacino di San Marco*. Oil on canvas. 18½ × 31 in. (47 × 78.8 cm.). The Duke of Bedford, Woburn Abbey, Buckinghamshire.
Another view looking up towards the Piazza San Marco from the Molo, seen from between the two columns, with the Doge's Palace on the right.

This picture was probably painted a few years after the preceding view of the Piazzetta, being one of a series of twenty-four commissioned by the fourth Duke of Bedford in about 1731. Notice how the artist's style is changing into something more rigid. The brush-strokes have lost their freedom to become more careful and precise, and the figures are smaller and neater. This is not to suggest that the painting is bad. On the contrary, the execution is very accomplished, and if it lacks spontaneity it still reflects a technique which, with so much practice, Canaletto was coming to perfect.

Plate 6 *The Molo: looking west*. Oil on canvas. 43½ × 73 in. (110.5 × 185.5 cm.). Senator Albertini Collection, Rome.
One of a pair (the other being a view of the Riva degli Schiavoni) painted sometime between 1742 and 1751, and closely corresponding to an engraving by Visentini.

Once again this view shows one of the best known aspects of Venice: in the right foreground is Saint Theodoric's column and the Library (as in plate 4); further up the Molo, and jutting out at a right-angle is the Fonteghetto della Farina. Across the water is the church of Santa Maria della Salute and next to it the Dogana (customs house).

This picture shows Canaletto's absolute control of perspective. Notice how the edge of the Molo runs almost directly up the centre of the canvas, and yet even so, the illusion of

recession has been achieved. An amusing detail is to be seen at the foot of the column, where a group of figures is occupied with bird-cages and hen-coops.

Plates 7 and 8 *The Grand Canal: Rialto*, and detail. Oil on copper. 18 × 23 in. (46 × 58.5 cm.). Goodwood Collection, Chichester.

One of a pair of paintings purchased from Canaletto by Owen McSwiney on behalf of the second Duke of Richmond. It cannot be later in date than 1727, when the pair is specifically mentioned by McSwiney in a letter to the Duke. Paintings on copper by Canaletto are rare and confined to his early years.

On the left is the Fondaco dei Tedeschi and on the right, the Naranzeria (Orange Market) in front of the Palazzo dei Camerlenghi. The Rialto Bridge, crossing the Grand Canal about half-way up its length, was built in 1589 by Antonio (or Giovanni) Contino, called da Ponte. The covered central part housed small shops, very much like the old London Bridge or Pulteney Bridge at Bath.

The detail (plate 8) shows something of Canaletto's mastery of surface textures. Notice the cool green water, rippled by the boats which move across it. Notice also the under-side of the arch of the bridge and the wall of the house on the right. The wetness of the water and the dryness of the plaster are almost tangible. Although this quasi-photographic accuracy is not always commended today, the degree of skill which produced it must always be admired.

Plates 9 and 10 *The Bacino di San Marco*, and detail. Oil on canvas. 49⅛ × 60¼ in. (125 × 153 cm.). Museum of Fine Arts, Boston. Gift of Miss Caroline Louise Williams French.

The main thoroughfare of Venice is the Grand Canal, which broadens out into the Bacino di San Marco, as is seen here.

On the left shore is the Molo, the Doge's Palace and the Riva degli Schiavoni. On the island in the distance is the church of San Giorgio Maggiore and to the right of the island, the end of the Giudecca with S. Giovanni Battista (since demolished). Beyond S. Giorgio is the island of Santa Elena. In the foreground are a variety of vessels including gondolas and fishing-boats. The big three-masted vessel in the centre adds some interesting detail and is also largely instrumental in holding the whole composition together. In fact the positioning of all the boats, although apparently haphazard, is extremely carefully worked out.

It is not safe to establish the date of a painting solely on grounds of evidence of the buildings portrayed. Canaletto quite often painted views based on old and out-of-date drawings, with the result that, at the time of execution, the painting showed buildings which had disappeared or had been altered some ten years before. In this case, however, it is not unreasonable to suggest that the painting must have been done after 1728, since before that date the church of S. Giorgio Maggiore had no onion-domed steeple. For similar reasons, it must have been painted before 1745, for in this year building began on the church of the Pietà; in this painting the site of the church is occupied by a group of half-ruined houses. A date in the early 1730s has been suggested on stylistic grounds.

Plates 11, 12 and 13 *The Doge visiting the Church and Scuola di S. Rocco*, and details. Oil on canvas. 58 × 78½ in. (147 × 199 cm.). The National Gallery, London.

Saint Roch is the patron saint of those threatened with or afflicted by the plague. In 1478 a confraternity in his name had been founded in Venice, and the saint's relics were transferred there from Germany in 1485. It was through the intercession of Saint Roch that Venice was spared the plague in 1575, and every year thereafter, on August 16th, it was

customary for the Doge to visit the church of Saint Roch.

In this painting the church (on the right) is seen during course of reconstruction. It was not completed until 1771. The marble sculpture of *Saint Roch carried to Heaven* by G. Marchiori, destined for the lunette over the door, is known to have been in position by 1743, so that the painting must presumably be before that date (1730-35 is the most likely time of execution).

The Scuola (in the centre) was the headquarters of the confraternity. The building dates from the first part of the sixteenth century and is probably the work of the architect Bon. Inside it is the famous series of religions paintings by Tintoretto.

It was traditional on Saint Roch's Day to exhibit pictures, both by living and dead artists, in the square. Some can be seen attached to the walls of the Scuola and adjacent houses.

In the centre of the Campo di S. Rocco is the Doge, wearing a cape of ermine over golden robes, walking under the state umbrella. He is surrounded by members of the Signoria, the diplomatic corps and members of the confraternity. The scarlet figure preceding the Doge is probably the *Cancelliere Grande*. Other officials have been tentatively identified. The bunches of flowers being carried by the Doge and his retinue were presented to them on arrival by the confraternity. They symbolise protection against the plague. Also note that the windows of the Scuola have been hung with garlands.

It is interesting to compare the figures in this painting with those in an earlier work (plate 4). Whereas before there are one or two groups strategically placed, here the foreground is filled to capacity, and yet each person is separately delineated, neat and compact. In later paintings Canaletto reduces his crowds to a series of suggestive blobs.

The roof garden in the upper left (plate 13) is the kind of detail that Canaletto delighted to make full use of. It might be compared with the etching of *The Terrace* (figure 9).

Plate 14 *SS Giovanni e Paolo and the Scuola di San Marco.* Oil on canvas. 36 × 53½ in. (91.5 × 136 cm.). Mrs Howard Pillow, Montreal.

An early work. One of a pair commissioned by Stefano Conti in 1725 and finished by the middle of 1726. Conti in fact commissioned two pairs of paintings from Canaletto and in each case the contracts, certificates and receipts have survived. There also exists a correspondence between Conti and his agent Alessandro Marchesini, from which we learn that there was a quarrel with the artist over the price: Canaletto first demanded 30 *zecchini* for each painting but later settled for 80 *zecchini* for all four. There was also discussion about the expensive pigments that Canaletto wished to use, and about the subject of each view.

Stefano Conti, a native of Lucca, was a silk and cloth trader. Many Venetian and Bolognese artists received commissions from him.

On the right of the Rio dei Mendicanti is the façade of the west end of SS. Giovanni e Paolo. In the square is Verocchio's famous monument to General Bartolomeo Colleoni, erected in 1496. Adjoining the church is the Scuola di S. Marco.

Plate 15 *The Grand Canal: looking from Santa Maria della Carità towards the Bacino di San Marco.* Oil on canvas. 35½ × 52½ in. (90 × 132 cm.). Mrs Howard Pillow, Montreal.
On the right is the church and campanile of Santa Maria della Carità, and the shadow thrown on to the façade of the church is that of the Scuola della Carità. The Campanile collapsed in 1744 and was not rebuilt. The church and scuola were suppressed in 1744 and the buildings are now part of the Accademia.

An early work, being one of a set of four paintings commissioned by Stefano Conti in 1726 (see note to plate 14).

Plates 16 and 17 *The Grand Canal: 'The Stonemason's Yard'.*
Oil on canvas. 48¾ × 64⅛ in. (124 × 163 cm.). The
National Gallery, London.
A painting of extremely high quality, probably executed in
1729-30.

The viewpoint is from the Campo San Vidal, looking
across the Grand Canal towards Santa Maria della Carita
(seen from a different angle in plate 15).

It is generally agreed that the open area in the foreground
is not a regular stonemason's yard but a temporary building
site—the church of San Vidal was undergoing reconstruction
at about this time. There is also the evidence of a drawing
at Windsor in which Canaletto shows the Campo cleared of
stone and without the wooden hut.

A point of interest is that Canaletto has omitted the curly
ornamental crockets from the top of the façade of Santa Maria
della Carità, although these appear in his other views of
the church (for example, plate 15). The well-head seen
close to the wooden hut is still in position to this day.

Plates 18 and 19 *The Grand Canal looking towards the Salute,*
and detail. Oil on canvas. 56 × 80½ in. (142 × 214 cm.).
Thyssen Bornemisza Collection, Lugano.
One of a set of four paintings formerly in the Liechtenstein
collection (see note to plate 1). An early work painted over
red ground, and freely, almost theatrically, handled.

Plate 20 *The Entrance to the Arsenal.* Oil on canvas. 18½ × 31
in. (47 × 78.8 cm.). The Duke of Bedford, Woburn Abbey,
Buckinghamshire.
The two brick towers beyond the wooden drawbridge are at
the entrance to the Arsenal. On the right is the former Oratory
of the Madonna dell'Arsenale, and the campanile of San
Francesco della Vigna is visible in the distance. One of
twenty-four views painted for the fourth Duke of Bedford.

The Duke had travelled on the Continent a year or two
before succeeding to the title in 1732 and it is likely that the
paintings were commissioned at that time. The Duke's
support is an instance of the type of patronage which enabled
Canaletto to make such a good living. Venice, like Rome, was
one of the places certain to be visited by anybody on a Grand
Tour, and to some extent Canaletto was fulfilling a need,
much as the picture-postcard does today. This is not to
suggest, however, that Canaletto's work was mere pictorial
photography.

Plate 21 *The Bucintoro Returning to the Molo on Ascension Day.*
Oil on canvas. 22 × 39 ½ in. (56 × 100.5 cm.). Dulwich
College Picture Gallery, London.
The Molo is seen from the Bacino di San Marco. Flanking
the Piazzetta are the Library and the Doge's Palace.

One of Venice's most important festivals, the Wedding
of the Sea, took place on Ascension Day. The origin of
the ceremony goes back, by tradition, to the Doge Pietro
Orsoleo's naval victory over Dalmatia in about the year
998, apparently on Ascension Day. Every Ascension Day
thereafter the Doge was rowed out to the Lido to confront
the sea, an act symbolising Venice's naval supremacy. Then
in 1178 the Doge of Venice received from the pope, in
gratitude for help in fighting the Emperor Frederick Bar-
barossa, a ring with which to wed the sea. This was not
unsuitable, as for centuries the sea had provided Venice
with effective protection against invaders and with the
opportunity to acquire great wealth through maritime trade.

On the morning of Ascension Day the Doge, with senators
and other officials, would go on board the Bucintoro (state
barge). He would be rowed to the Porta di Lido where the
ring, blessed by the patriarch, would be thrown into the
sea. After mass at San Nicolò del Lido, the Doge
returned to the Molo in the state barge. For this occasion

the Piazzetta was covered with stalls and trading booths.

Plate 22 *The Molo: the Fonteghetto della Farina*. Oil on canvas. 14½×20 in. (37×51 cm.). Museum of Fine Arts, Boston.
Probably painted in the early 1730s. The Fonteghetto della Farina was then the headquarters of the Magistrato della Farina, a body which controlled the supply of wheat to Venice. Subsequently the building was used for different purposes (including housing the Collegio dei Pittori for a time).

Plates 23 and 24 *A Regatta on the Grand Canal*, and detail. Oil on canvas. 48 × 72 in. (121 × 183 cm.). The National Gallery, London.
The Regatta originated in the fourteenth century as a rowing competition. A decree of 1315 states that there should be a regatta every year on February 2nd (the Feast of the Purification), and that two barges should be built for it in the Arsenal. There was a prescribed course, at the end of which a special pavilion (*macchina della regatta*) was erected. Here the winners were presented with coloured flags. In time the regatta became more and more of a spectacle connected with the carnival. It was also staged in honour of important visitors.

In this painting the *macchina* is on the left, and decorated with the arms of the Doge Alvise Pisani. On the right are the specially decorated barges.

A date between 1735 and 1740 has been suggested.

Plate 25 *SS Giovanni e Paolo and the Colleoni Monument*. Oil on canvas. 16¼ × 13¼ in. (41 × 33.5 cm.). Lord Brownlow, Grantham.
Compare with plate 14. The view is across the Rio dei Mendicanti towards the Colleoni monument, with SS Giovanni e Paolo on the left. A man is sketching the monument.

By taking up a viewpoint so close to the monument, Canaletto has involved himself in a difficult exercise in perspective. The result is rather unusual.

Plates 26 and 27 *The Campo San Stefano*, and detail. Oil on canvas. 18½ × 31½ in. (47 × 80 cm.). The Duke of Bedford, Woburn Abbey, Buckinghamshire.
An attractive view of a typical Venetian *campo*. The feeling of a space enclosed is well produced.

One of the group of twenty-four views painted for the fourth Duke of Bedford (see note to plate 20).

Plate 28 *The Night Festival at San Pietro di Castello*. Oil on canvas. 46⅞ × 72⅞ in. (119 × 185 cm.). On loan to Staatliche Museen, Gemäldegalerie, Berlin Dahlem.
This festival took place on the Eve of St Peter's Day (June 29th). It was one of four night festivals, the other three being at Santa Marta, the Redentore and on Christmas Eve in the Bacino di San Marco.

Across the canal is the church of S. Pietro di Castello, and to the right of it the residence of the Patriarch of Venice.

Night scenes by Canaletto are excessively rare but there is a pair to this one, showing the festival at Santa Marta. This pair, together with two other paintings by Canaletto, was formerly in the collection of Sigmund Streit. Streit was a German banker who spent all his working life in Venice and retired to live in Padua. In 1763 he presented his books and paintings to his old school, the Gymnasium zum Grauen Kloster.

Plate 29 *A View of Dolo on the River Brenta*. Oil on canvas. 24 × 37½ in. (61 × 94.6 cm.). Ashmolean Museum, Oxford.
Dolo is a small town on the Brenta, half-way between Padua and the Venetian lagoon. Notice the warm, bland colours

which Canaletto has used, and also the careful placing of the group of figures in the left foreground. A date of about 1728 has been proposed. If that is correct, then the *View of Dolo* becomes the only known example of a view outside Venice painted by Canaletto in the 1720s.

Quite close in style are three etched views of Dolo which date from the early 1740s.

Plate 30 *Padua: Prato della Valle*. Oil on canvas. 15¾ × 34½ in. (40 × 87.5 cm.). Lord Brownlow, Grantham.
The Prato della Valle was a stretch of marshy common land in the middle of Padua. It was used for fairs and horse-racing. The buildings round the edge are, from left to right: Scuola delle Cormari, Santa Giustina with adjacent monastery, Chiesa della Misericordia (now gone), Palazzo Verson (formerly Grimani) and the Collegio Universitario. The Prato was the object of ambitious schemes for improvement in the eighteenth century, none of which was entirely realised. It was, however, drained in 1775 and somewhat altered. It is now called the Piazza Vittorio Emanuele II.

There are two related drawings at Windsor which, when joined up, give the whole panorama. There is also an etching. Both drawings and etching are very close to the painting except in small details.

Plate 31 *London: The Thames and City seen from Richmond House*. Oil on canvas. 41¾ × 46¼ in. (105 × 117.5 cm.). The Goodwood Collection, Chichester.
Painted for the second Duke of Richmond who, through the agency of Owen McSwiney, had been one of the earliest patrons of Canaletto in 1726-27.

This painting (with its pair, the *View of Whitehall from Richmond House*) was thought to have been one of Canaletto's first products after arriving in London in May, 1746. It has now been suggested that the pair dates from 1747.

Plate 32 *London: The Thames seen from the Terrace of Somerset House, looking towards St Paul's* (detail). Oil on canvas. 43 × 73 in. (106.5 × 185.5 cm.). The Royal Collection, Windsor.
There is a companion painting of *The Thames from the Terrace of Somerset House looking towards Westminster*: both views were probably painted in Venice in 1750.

The pair of Thames views from Somerset House are amongst the best of Canaletto's English paintings. The handling of the subject is sympathetic and the details felicitous. The river Thames, bathed in a warm, clear light, has almost been transformed into a Venetian waterway. It is the kind of painting that Canaletto's patrons in England expected from him but did not always obtain. It is also the kind of painting that was emulated by the English followers of Canaletto such as Scott and Marlow.

In this view the terrace of Somerset House is in the left foreground. Further away is the dome of St Paul's, clearly visible among the spires of other City churches.

Plate 33 *London seen through an Arch of Westminster Bridge*. Oil on canvas. 22 ½ × 37 ½ in. (57 × 95 cm.). The Duke of Northumberland, Alnwick, Northumberland.
The arch still has its wooden supporting structure in position, providing the artist with an unusual frame for the composition. Notice also the workman's bucket suspended below the arch, thus effectively breaking the symmetry. On the left bank are the Water Tower, Somerset House and the spire of St Clement Dane's. The river curves round out of sight but its course can be gauged by St Paul's.

Probably painted for Sir Hugh Smithson, first Duke of Northumberland, shortly after Canaletto's arrival in England. The last arch of Westminster Bridge was keyed in July, 1746, and the wooden supports would have been removed soon afterwards.

Plates 34 and 35 *London: Westminster Bridge from the North on Lord Mayor's Day* and detail. Oil on canvas. 37¼ × 50¼ in. (96 × 137.5 cm.). Mr and Mrs Paul Mellon Collection, Washington D. C.

This view shows Westminster on the right bank and Lambeth Palace on the left, in the distance. Westminster Bridge was finished in late 1746. An engraving of the picture was published in 1747 so that the accurate dating is possible.

The barges on the river are transporting the new Lord Mayor (escorted by the City Companies), from the City to Westminster for the ceremony of swearing in before the Barons of the Exchequer.

Plates 36 and 37 *London: Whitehall and the Privy Garden*, and detail. Oil on canvas. 46¾ × 93½ in. (118.5 × 273.5 cm.). The Duke of Buccleuch and Queensbury, Selkirk.

A very fine painting. On the extreme right is Richmond House (see plate 31) and the stables. Next door is Montagu House and through the gap between the two houses can be seen the river and St Paul's. In the centre is a wall separating the Privy Garden (on the right) from Whitehall. Notice how this wall cuts right down the middle of the composition; few other artists would have attempted such an uncompromising problem of perspective. At the end of the Privy Garden is the Banqueting Hall. Opposite that is the Holbein Gate (demolished in 1759). In the left foreground is a building site.

Probably painted in the early 1750s. It is not known whether Canaletto painted this view on commission, only to find it left on his hands, or whether he painted it as a speculation. At any rate the painting went back with him to Venice and was eventually purchased from him in 1760 by John Crewe.

Plate 38 *London: The Old Horse Guards seen from St James's Park*. Oil on canvas. 48 × 98 in. (122 × 249 cm.). The Earl of Malmesbury, Basingstoke.

The Old Horse Guards (the red-brick building in the centre) was demolished in 1749-50 and replaced by a new building. Nevertheless Canaletto may have painted the view at a later date, basing it on a very similar drawing (now in the British Museum). It was possibly painted as a speculation and may correspond with one advertised by the artist in the *Daily Advertiser*. In 1756 it was in the possession of the Earl of Radnor who describes it in a letter as 'the most capital picture I ever saw of that master'. Certainly it is a delightful painting and gives a very good picture of mid-eighteenth century London.

Plate 39 *Old Walton Bridge*. Oil on canvas. 18¼ × 29½ in. (465 × 75 cm.). Dulwich College Picture Gallery, London.
A view looking upstream from the Middlesex bank. The wooden bridge was constructed in 1750 by Samuel Dicker, M.P., whose house can be seen among the trees.

One of six paintings commissioned by Thomas Hollis, executed in 1754, and inscribed to that effect by Canaletto on the back of the canvas.

Plate 40 *Warwick Castle: the East Front from the Courtyard*. Oil on canvas. 29½ × 48 in. (75 × 122 cm.). The Earl of Warwick, Warwick Castle.
One of four views of Warwick Castle painted for Francis Greville, Earl Brooke (created Earl of Warwick in 1759). Probably painted at the same time as the views of Badminton (see plate 41).

Plate 41 *View of Badminton House, seen from the Park*. Oil on canvas. 33¾ × 48 in. (86 × 122 cm.). The Duke of Beaufort, Badminton House, Gloucestershire.
One of a pair (the other being a view of the park seen from

the house) commissioned by the third Duke of Beaufort. The views are mentioned by George Vertue in his notebook for mid-1749 and were probably painted in the summer of 1748.

Plate 42 *View of Alnwick Castle, Northumberland.* Oil on canvas. 44¾ × 55 in. (113.5 × 139.5 cm.). The Duke of Northumberland, Alnwick, Northumberland.
Commissioned by the first Duke of Northumberland, one of Canaletto's best patrons in England.

The Castle is shown before restoration by Robert Adam in 1752-53. The painting is one of Canaletto's least typical products. The treatment is harsh, almost crude, but it is not entirely unsuitable for a medieval castle in a rugged landscape.

Plates 43 and 44 *Landscape Capriccio with Column.* Oil on canvas. 52 × 42 in. (132 × 106.5 cm.). *Landscape Capriccio with Palace.* Oil on canvas. 52 × 41 in. (132 × 104 cm.). Both plates the National Gallery of Art, Washington, D.C. Gift of Mr Paul Mellon, on loan to the American Embassy, London.
In his mature and later periods Canaletto took to painting capriccii, imaginary compositions made up of landscape and/or architectural features. The attractions of painting capriccii were several: firstly, it was a change from straightforward view painting; secondly, by incorporating diverse objects into a unified composition, it was an exercise in ingenuity; thirdly, it was a chance to display technical virtuosity with extravagant perspectives and curious juxtapositions.

The pair illustrated form part of a group of which one canvas is dated 1754. Canaletto was in England at this time and it is probable that the whole group was painted then, intended as part of a decorative scheme. In the back-

ground of plate 43 is what appears to be Box Hill in Surrey, while the church on the left also has an English look. The palace on the right is definitely Italianate. Notice also the figures in the boat, one of which is holding a curious Chinese-style parasol. In plate 44 Canaletto has amused himself by putting Italian monuments into an English landscape.

Plate 45 *Capriccio: a Palace with a Clock Tower and a Roman Arch.* Oil on canvas. 39½ × 57½ in. (100.5 × 146 cm.). The Duke of Norfolk, Arundel, Sussex.
A good example of one of Canaletto's architectural capriccii. He often introduced well-known monuments in imaginary settings. In this case the arch on the left is very similar to the Arch of Titus in Rome and the dome could be that of St Peter's. Ornate flights of steps, fountains and striped awnings all contribute to the air of fantasy.

Plate 46 *Capriccio: a Colonnade opening on to the Courtyard of a Palace.* Oil on canvas. 51½ × 35½ in. (131 × 93 cm.). Galleria dell'Accademia, Venice.
Signed in the lower left *Anton 1765.* Presented by the artist to the Accademia di Pittura e Scoltura on his election in 1763. An effective, but rather 'academic' product.

Plate 47 *The Piazza San Marco showing Part of the Colonnade of the Procuratie Nuove.* Oil on canvas. 18 × 14 in. (45 × 35 cm.).

Plate 48 *The Piazza San Marco seen from the north west corner.* Oil on canvas. 18¼ × 14¾ in. (46.5 × 38 cm.). Both plates the National Gallery, London.
A pair of late works undoubtedly executed after Canaletto's final return to Venice. It is interesting to compare them with early views of the Piazza (for example plates 1 and 2). The handling is accomplished, if calligraphic and somewhat

slick. Although the views are absolutely faithful to reality, the effect is more like a clever, stage set. Notice especially the theatrical angle of the colonnades and how carefully the groups of figures are posed.

Plate 49 *Architectural Fantasy: a Flight of Steps leading up to the Loggia of a Palace*. Pen-and-ink drawing with grey wash. 14¾ × 20¾ in. (36.3 × 53.1 cm.). The Royal Collection, Windsor.
A drawing in Canaletto's later style but nonetheless a *tour de force*. The pen-work is worth looking at closely, and it is a good example of the artist's so-called calligraphic style. The chevron coat-of-arms attached to the corner of the loggia is the crest of the Canal family and a form of signature that Canaletto often employed.

All the virtuosity of Canaletto is displayed in this drawing. Solely by using pen and wash he has achieved contrasts of light and shade, intriguing perspective and an effective illusion of distance. As a work of art it can be considered quite as finished ˙and quite as effective as an oil painting.

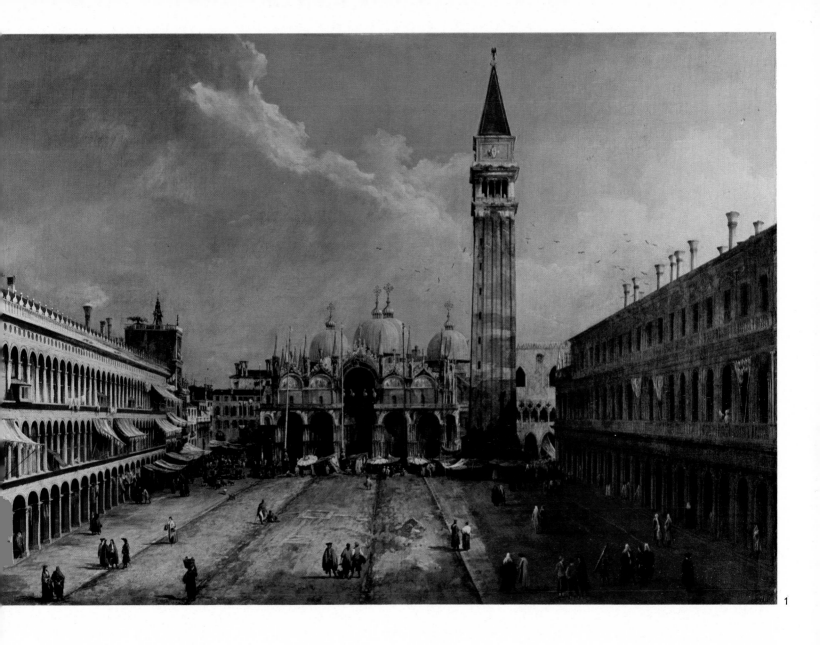

1

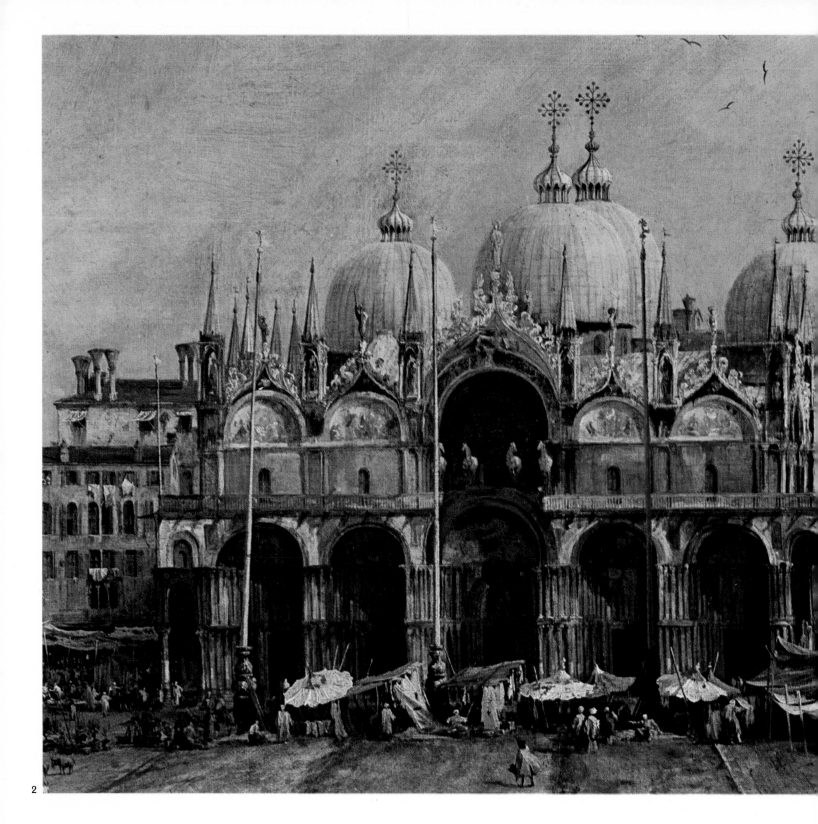

2

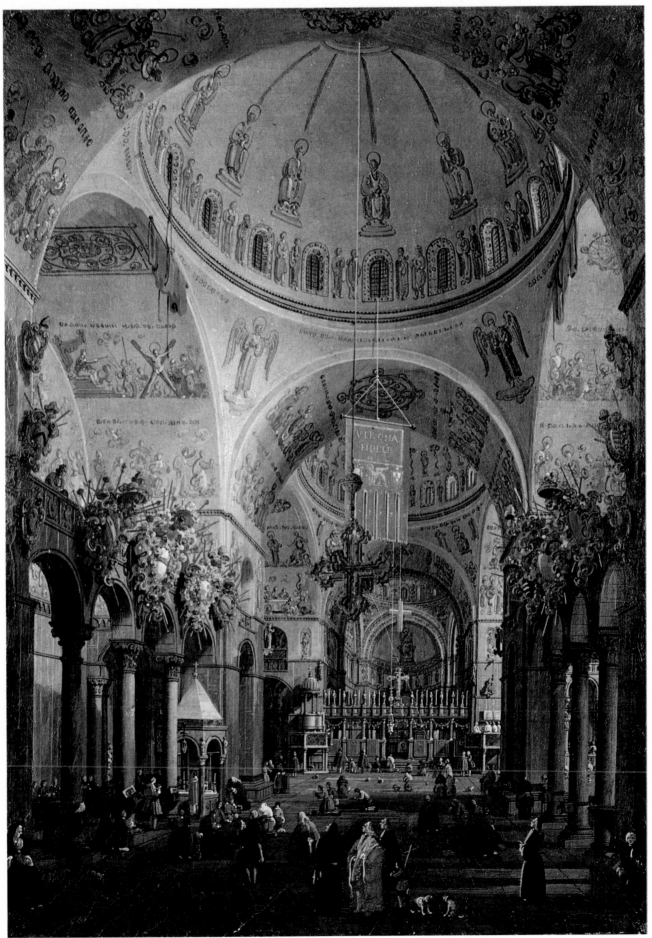

3

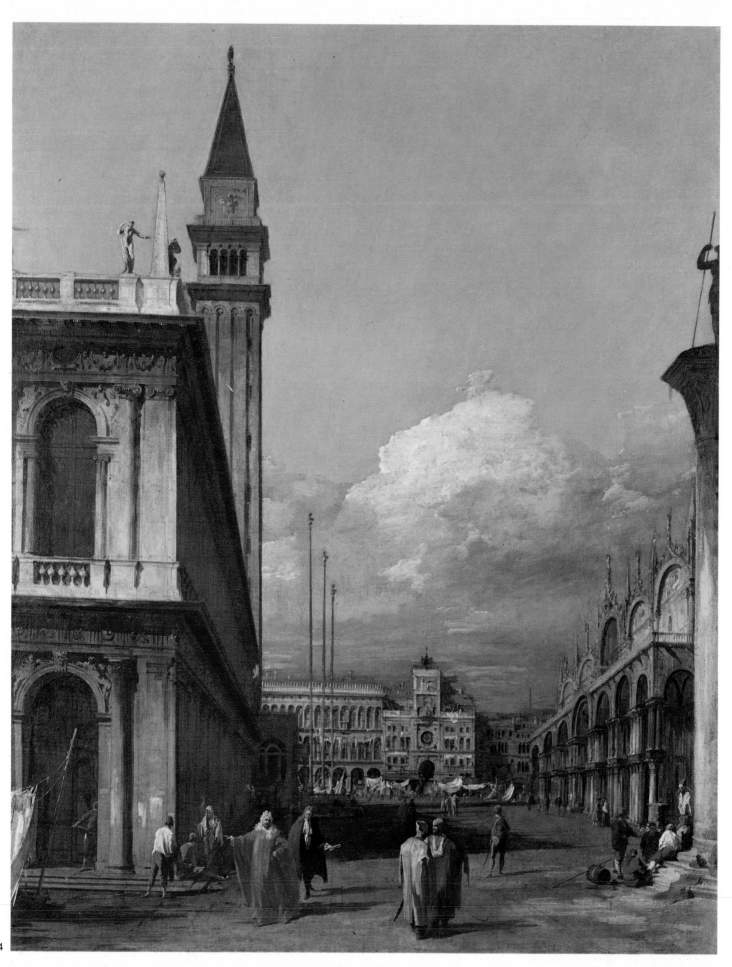

4

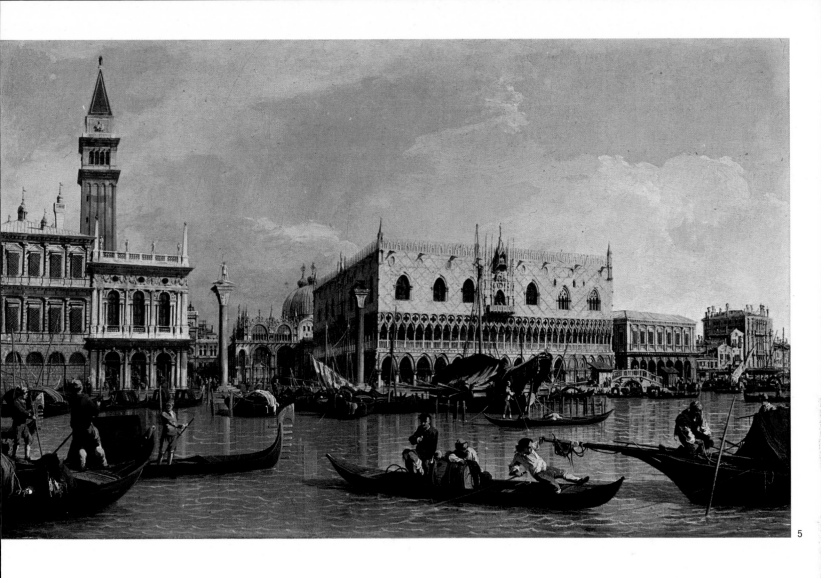

5

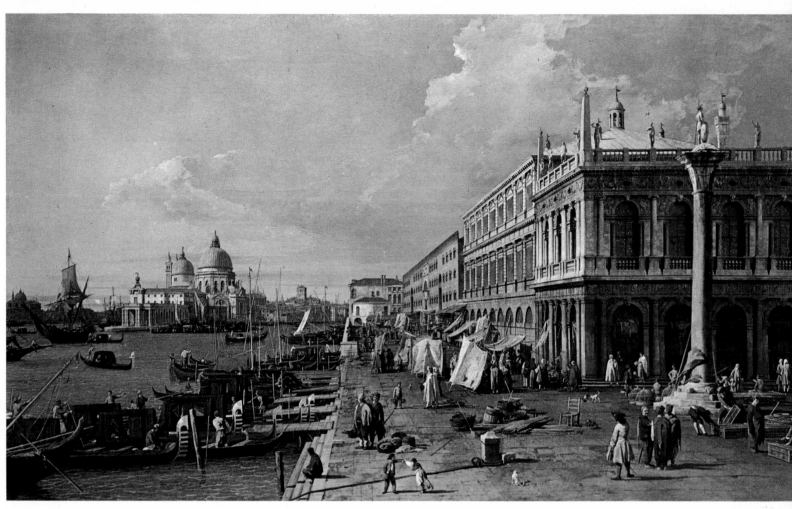

6

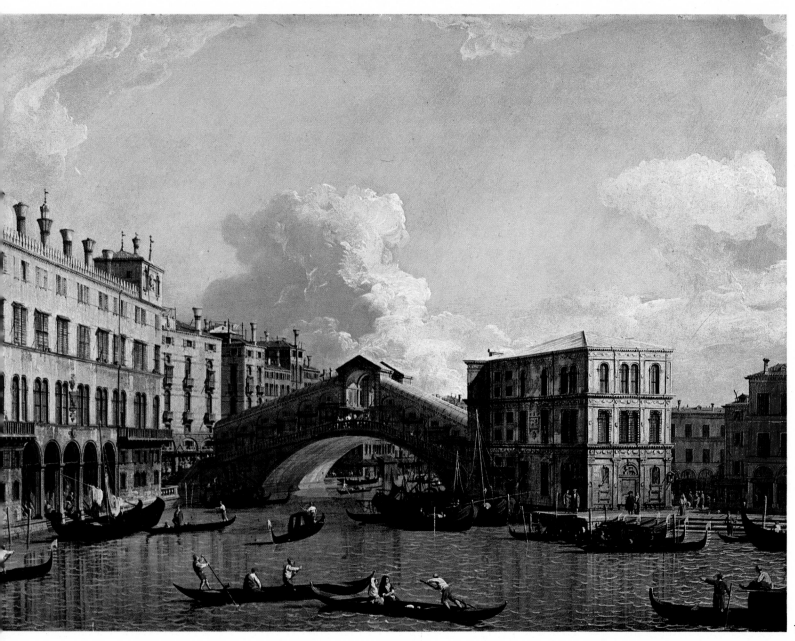

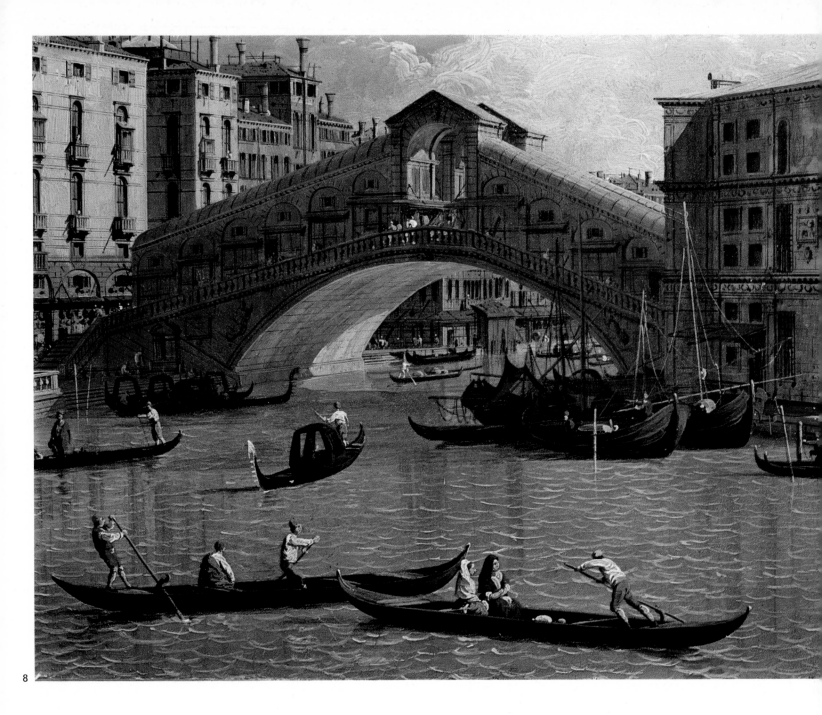

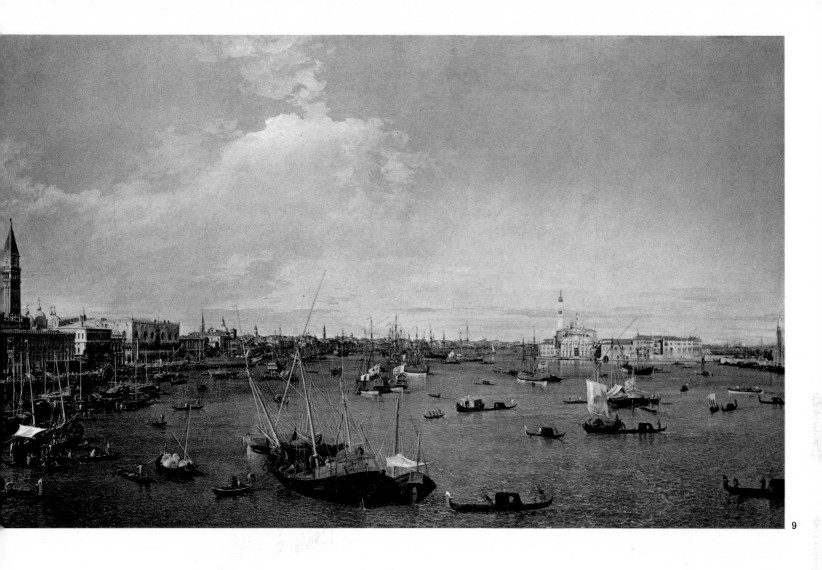

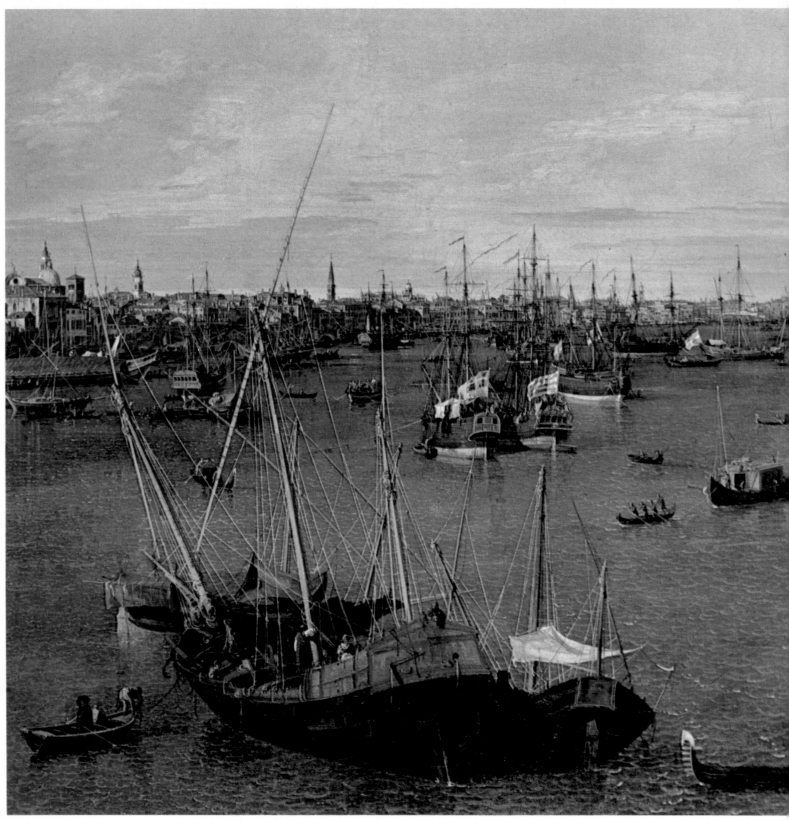

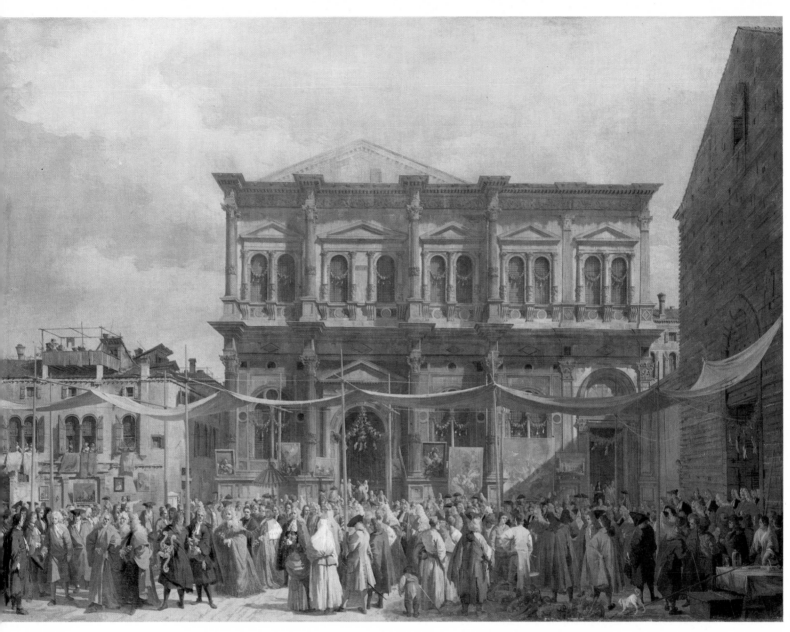

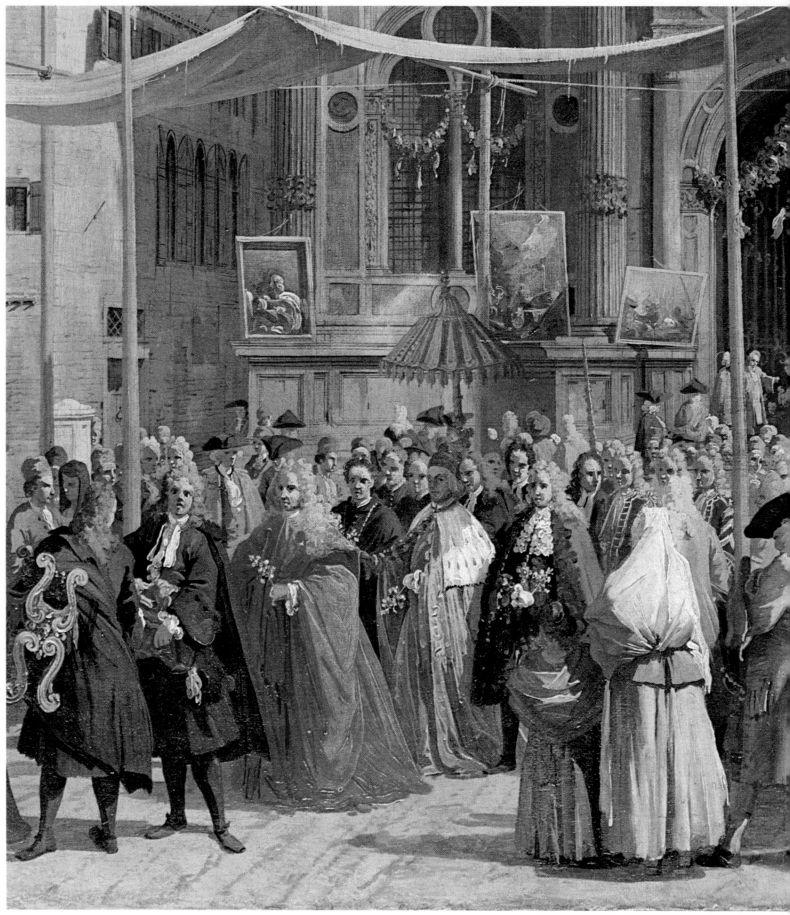

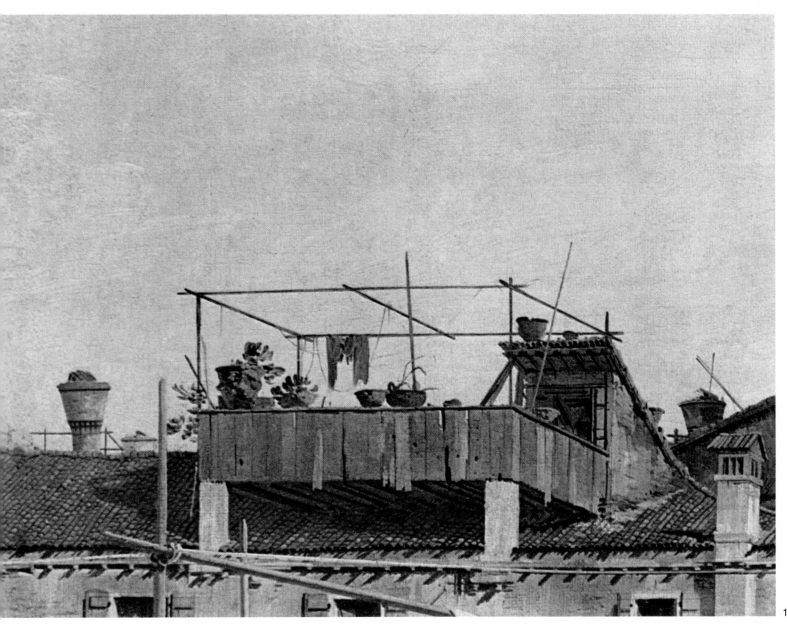

13

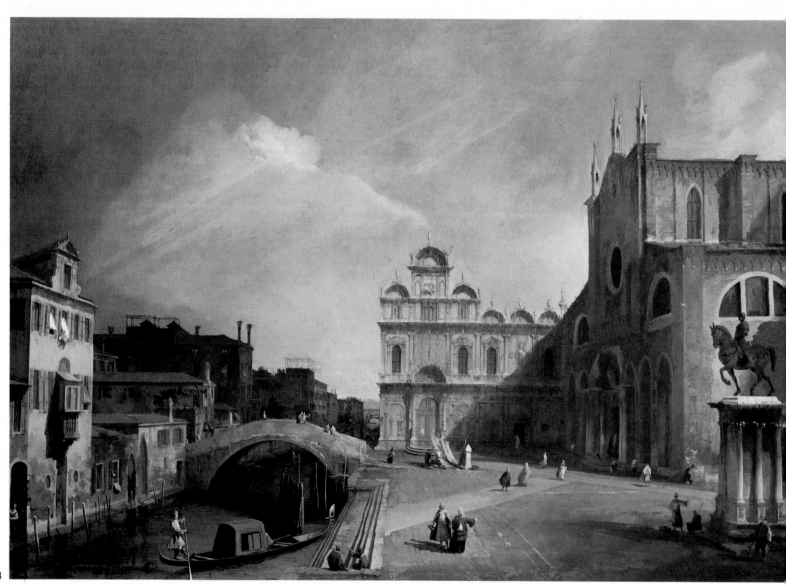

14

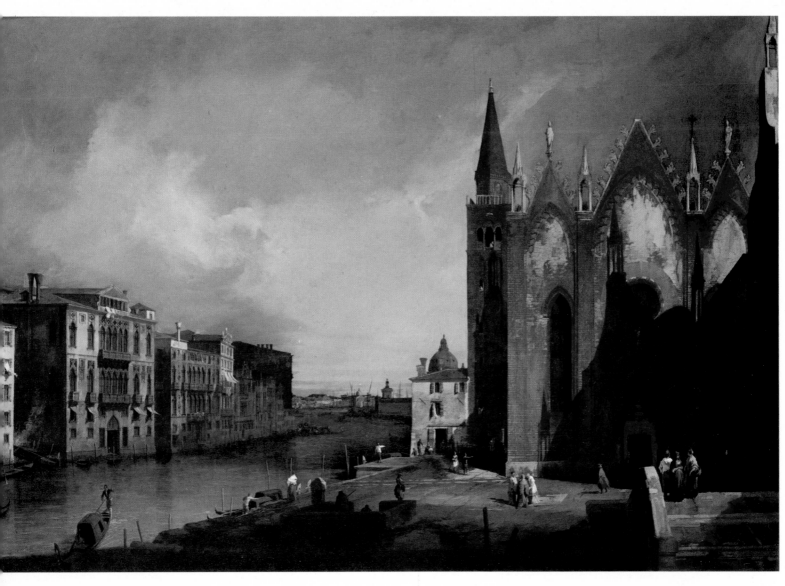

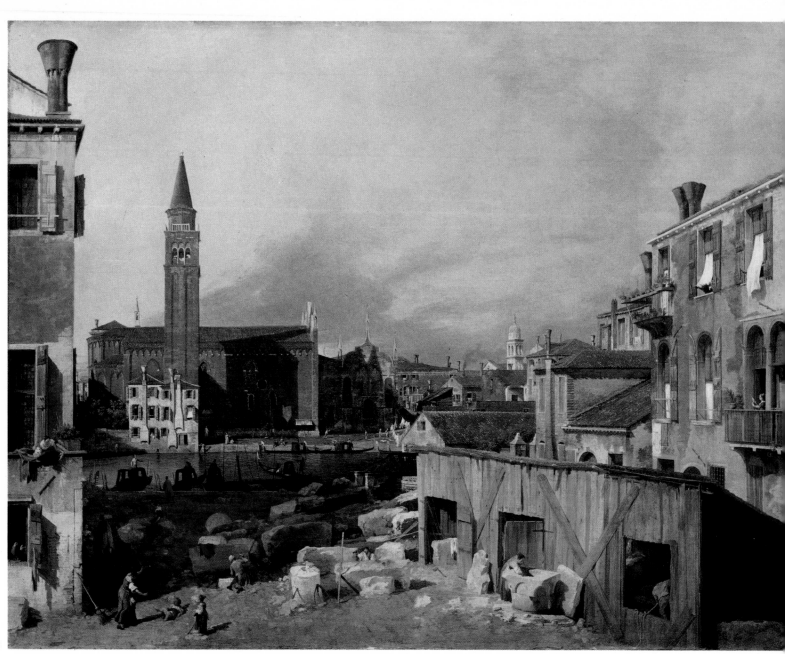

16

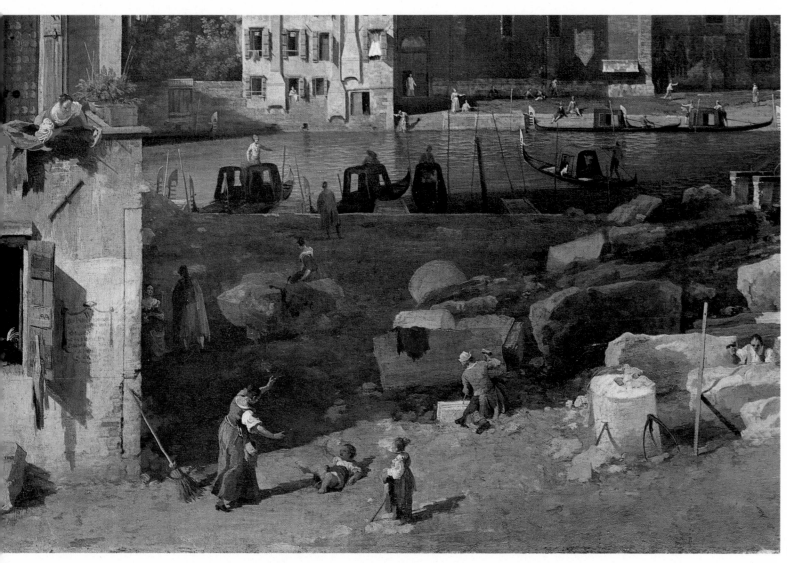

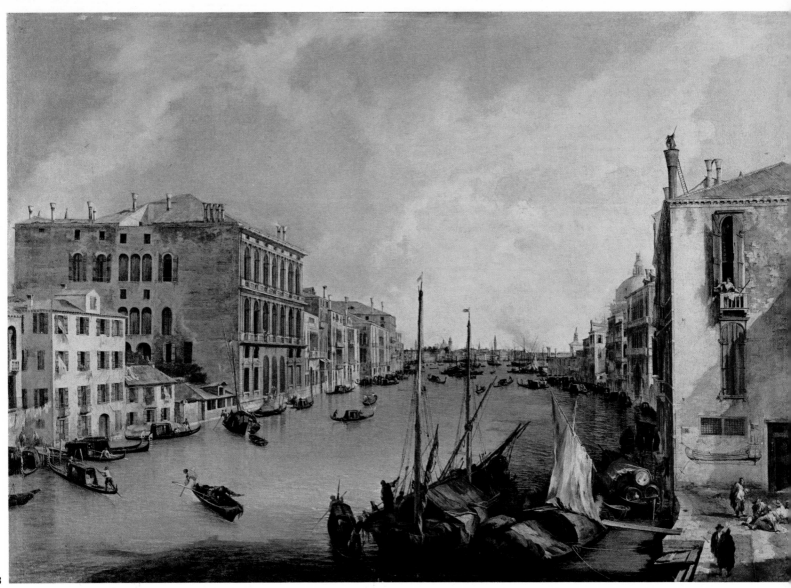

18

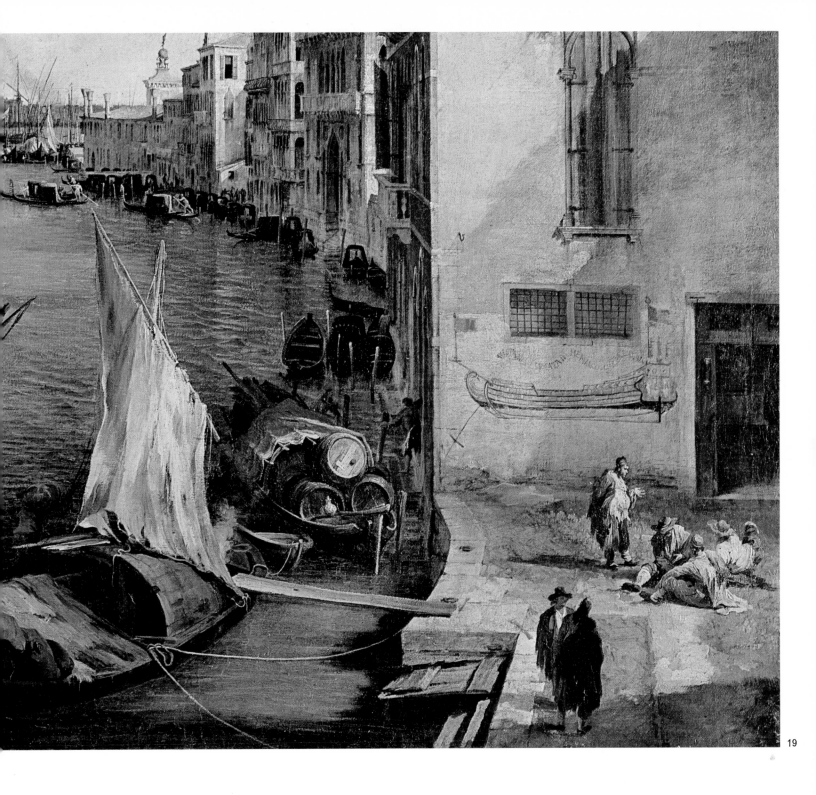

20

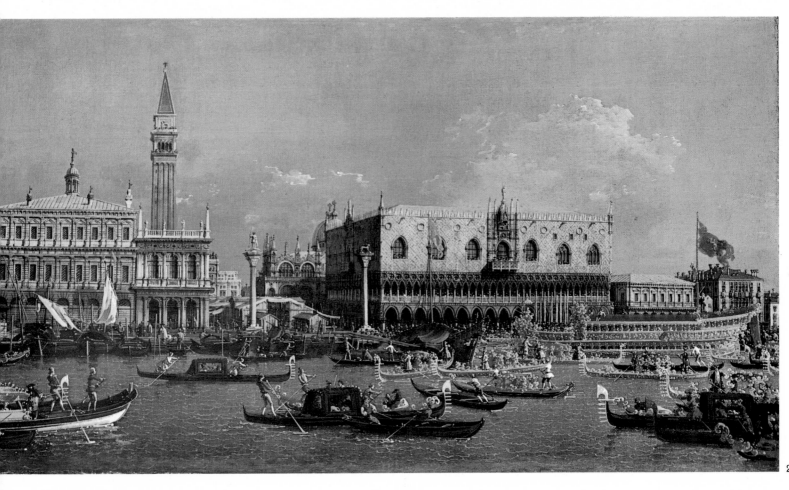

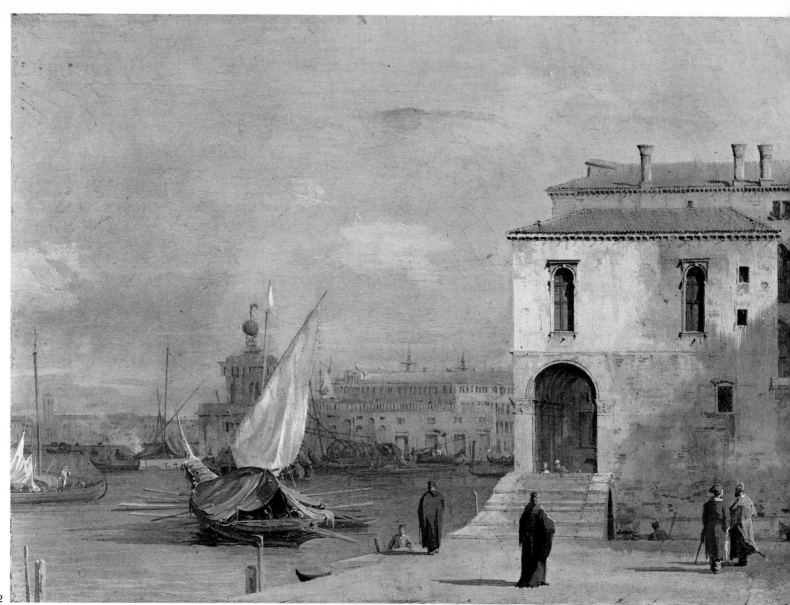

22

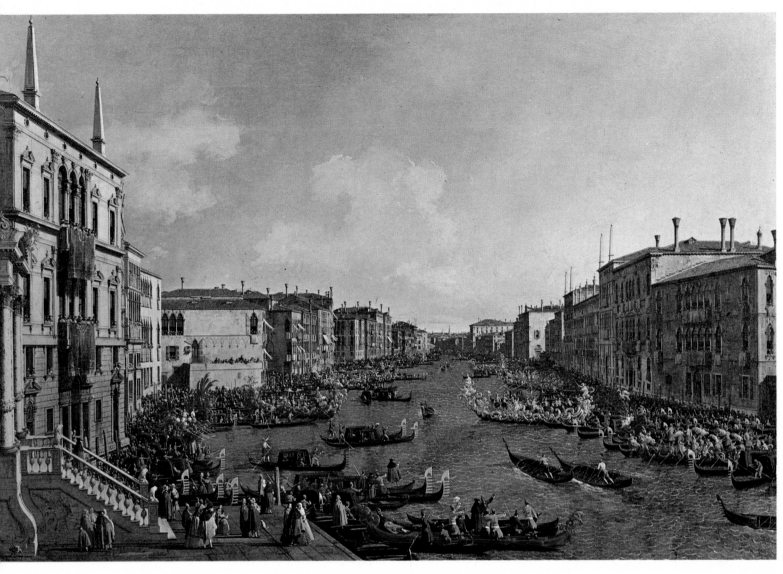

23

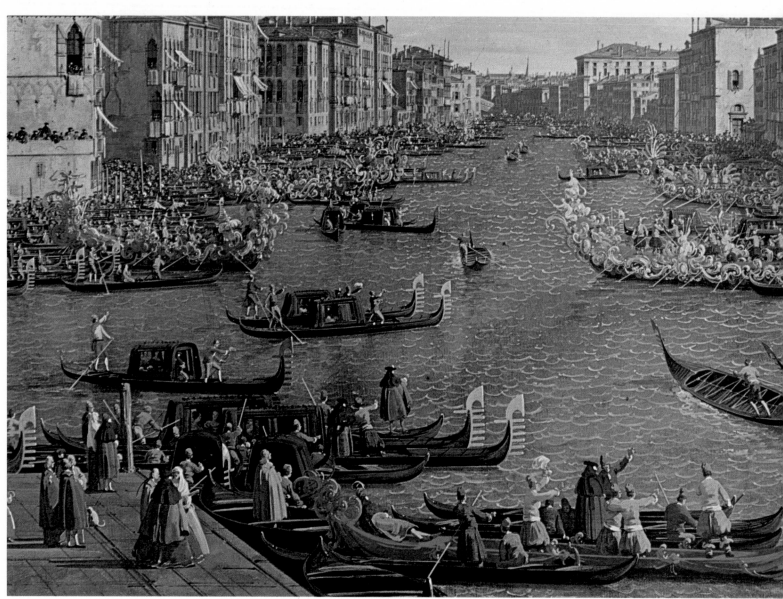

24

26

28

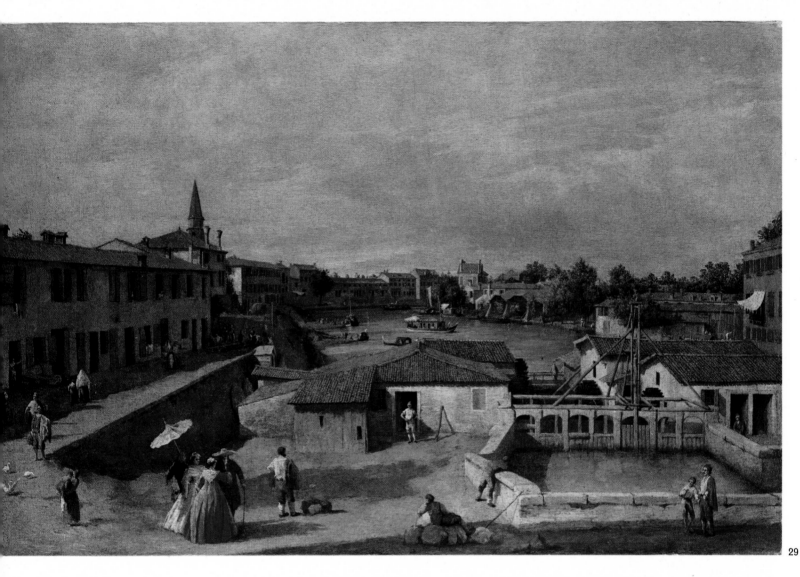

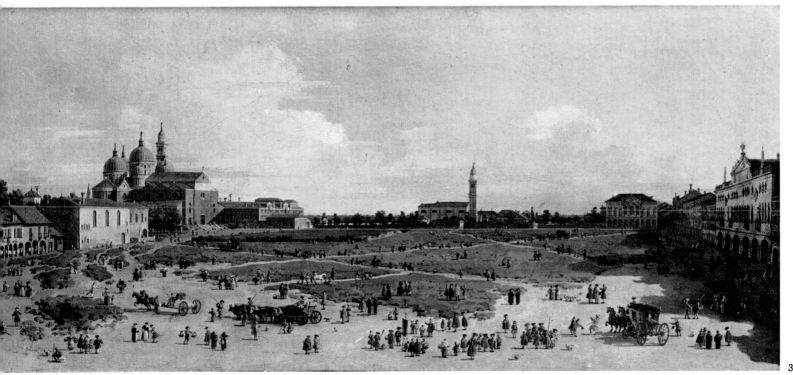

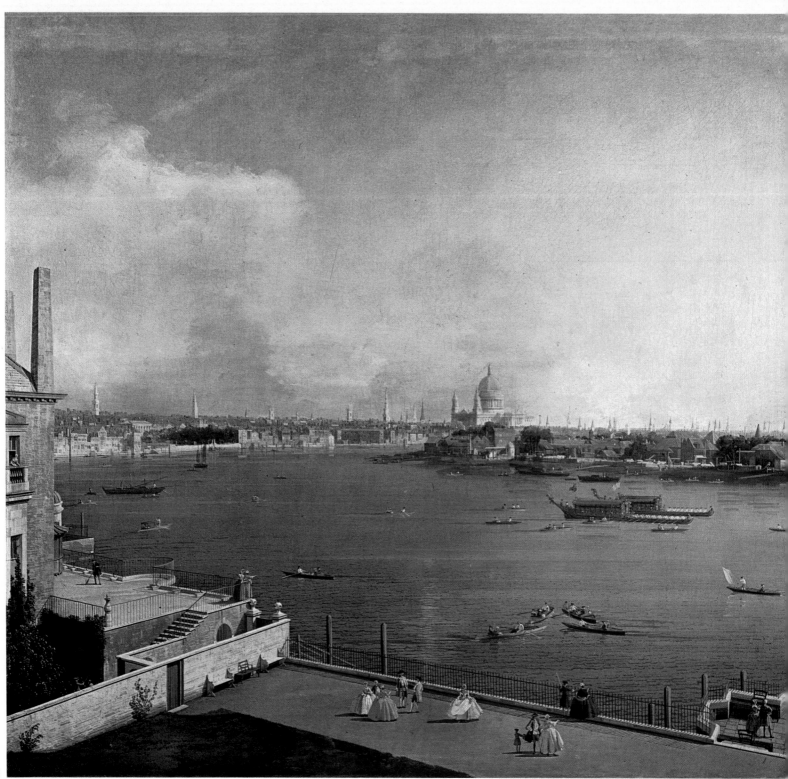

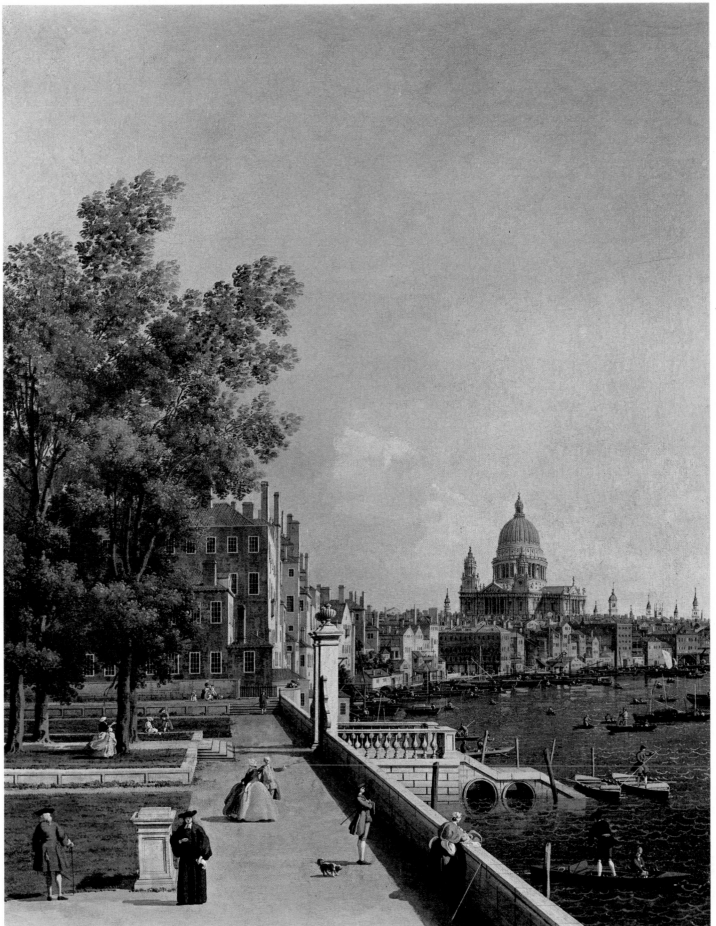

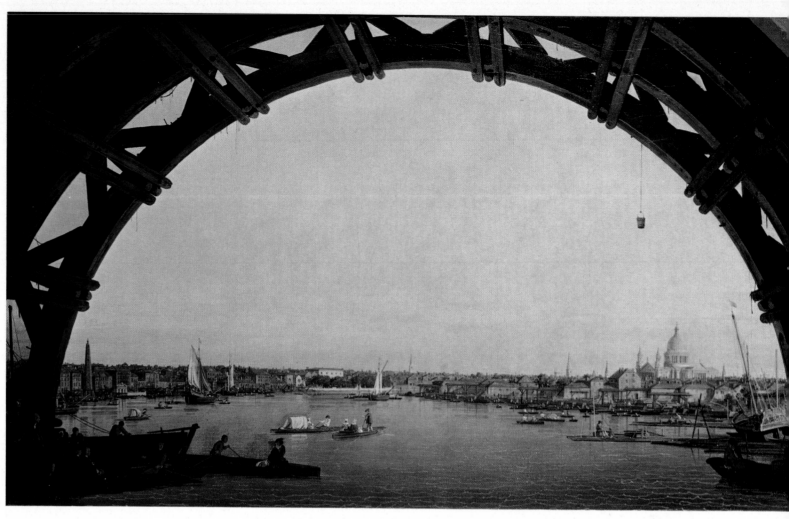

33

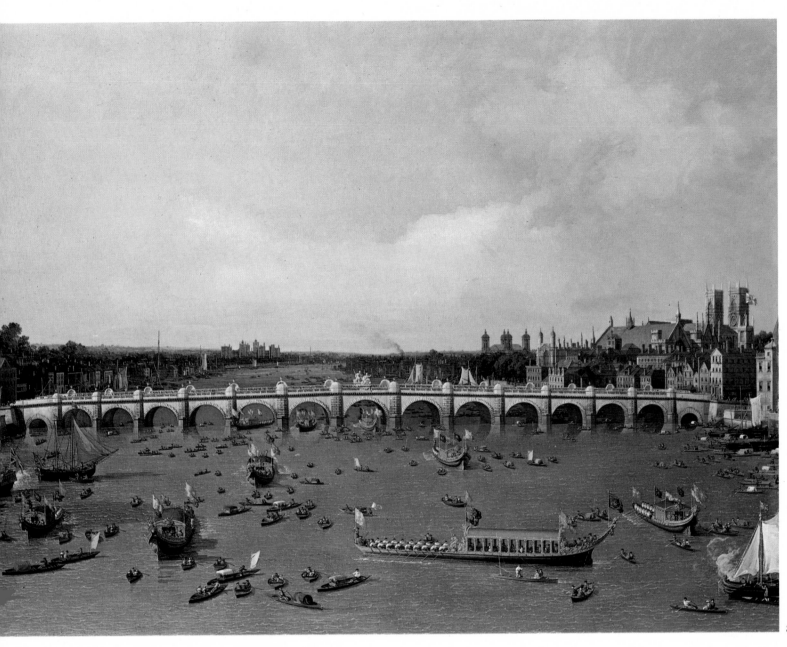

34

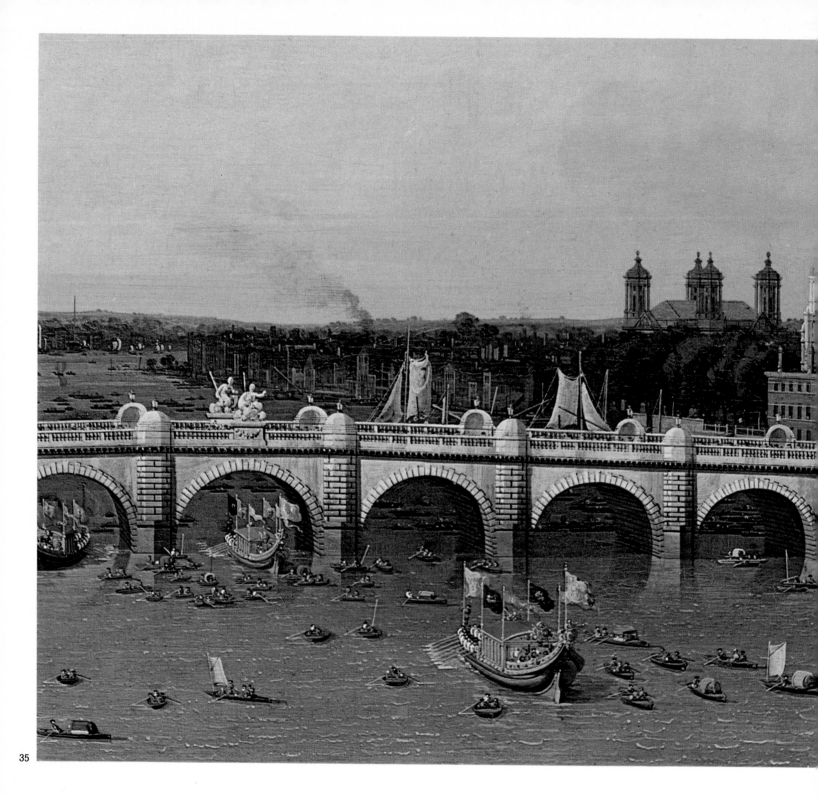

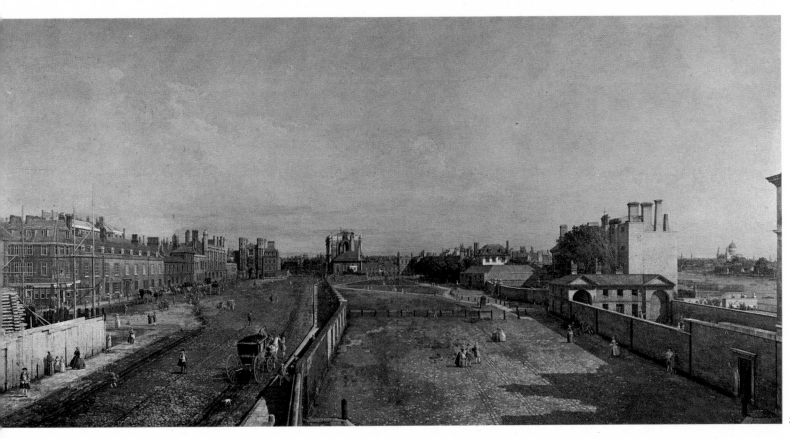

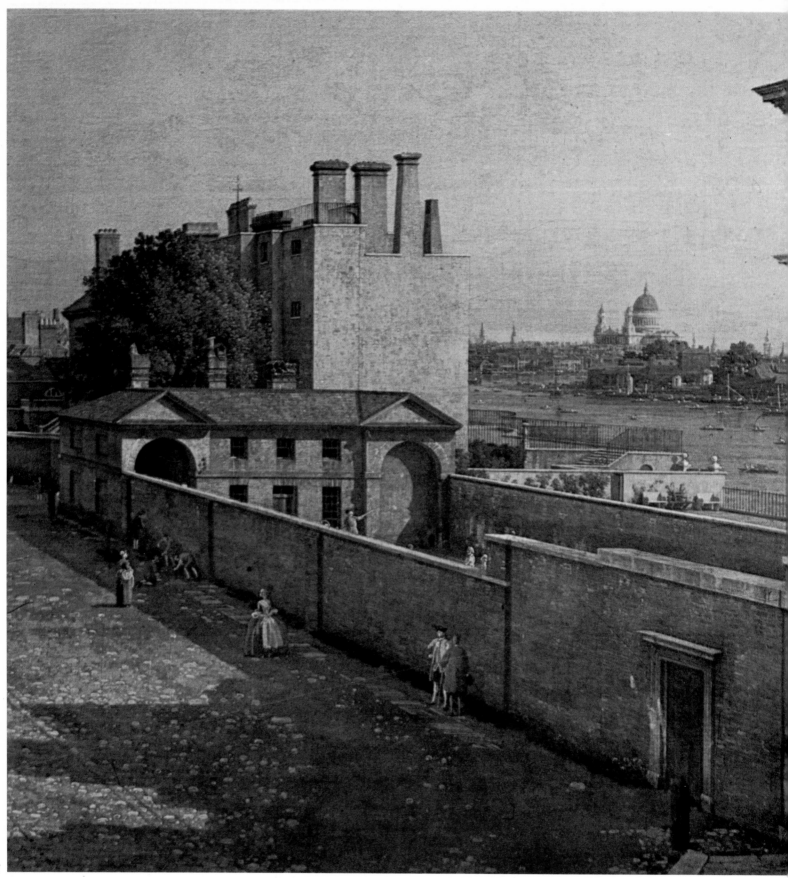

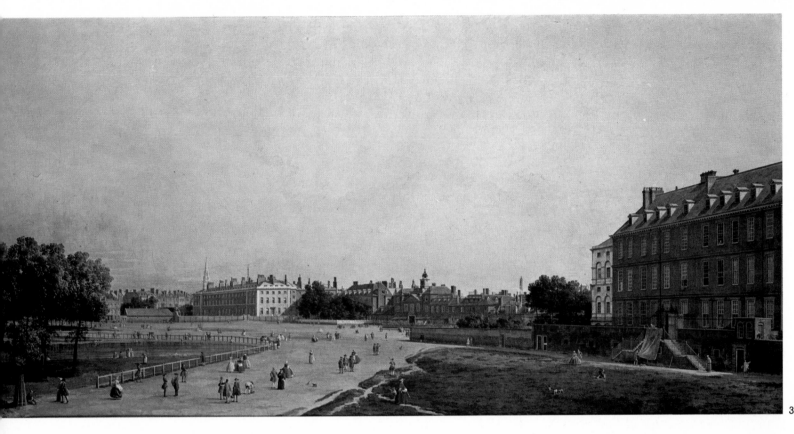

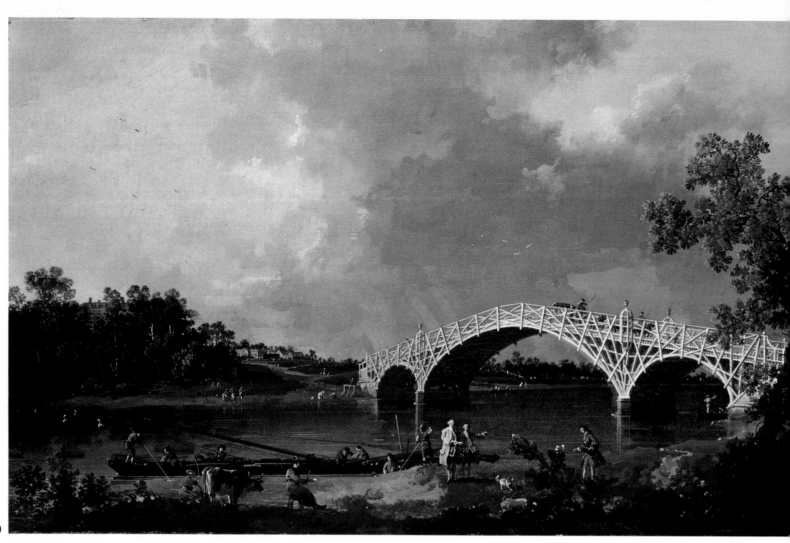

39

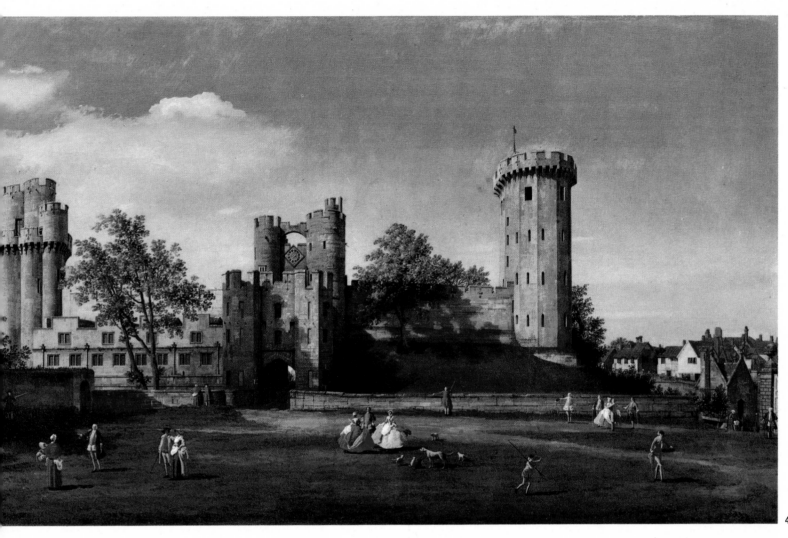

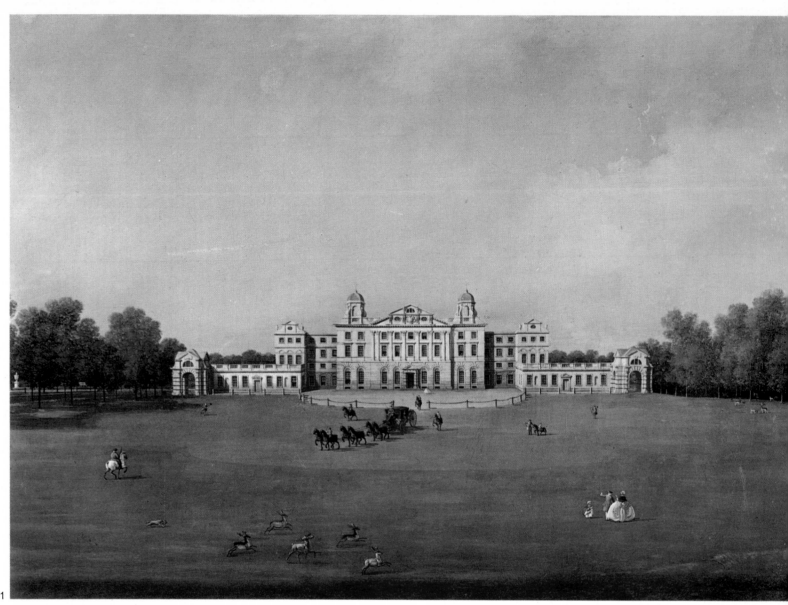

41

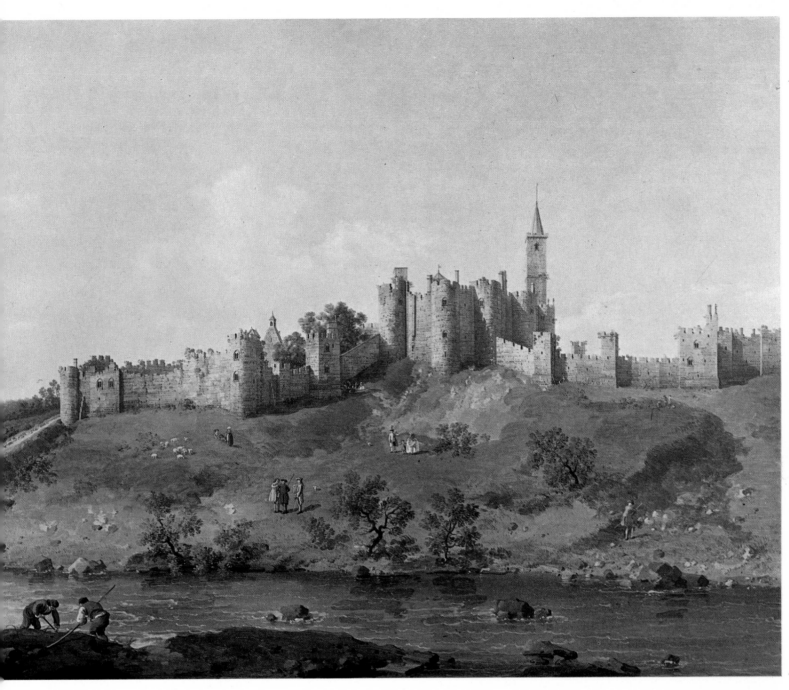

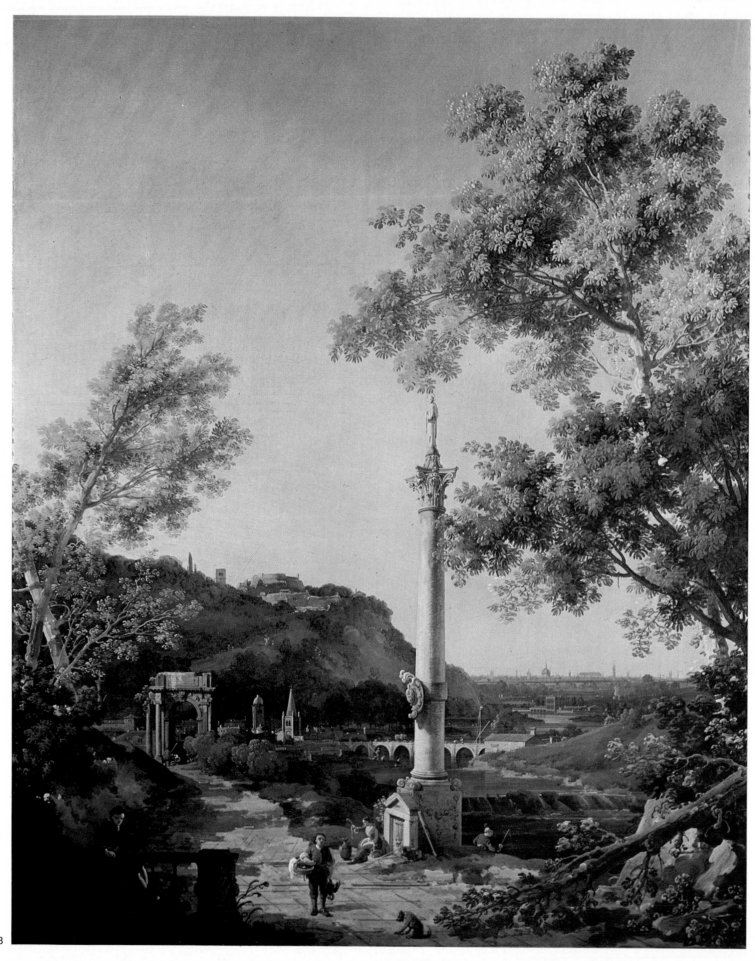

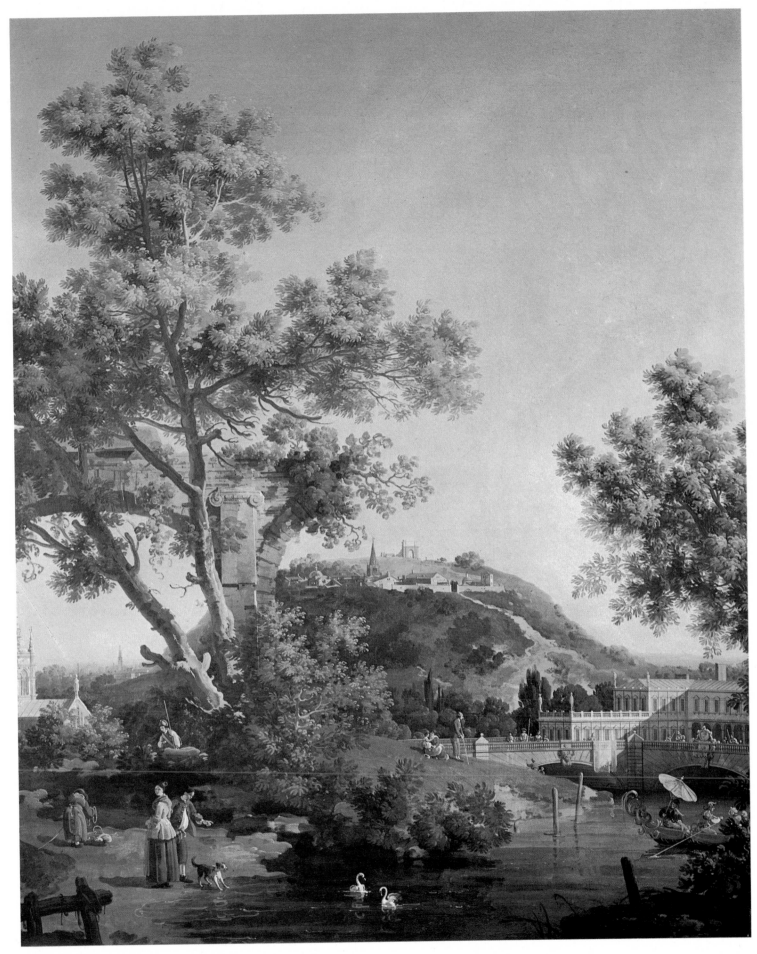

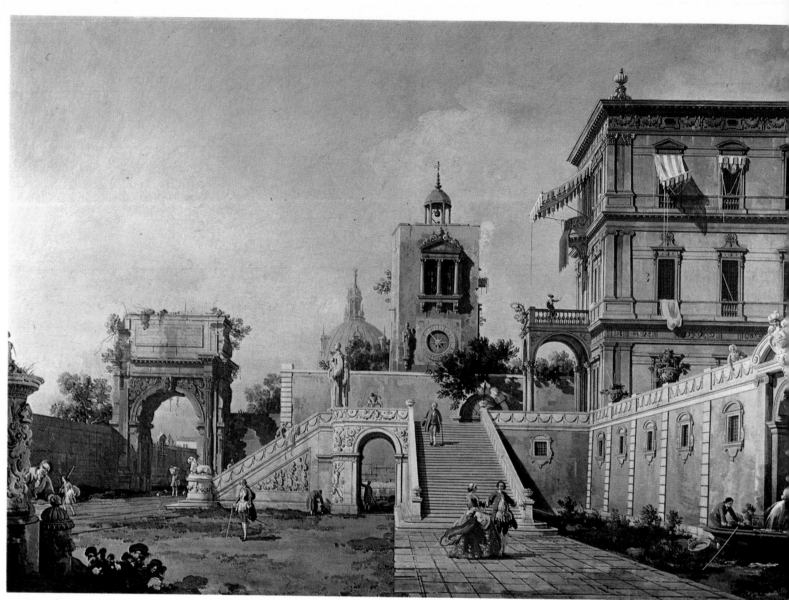

45

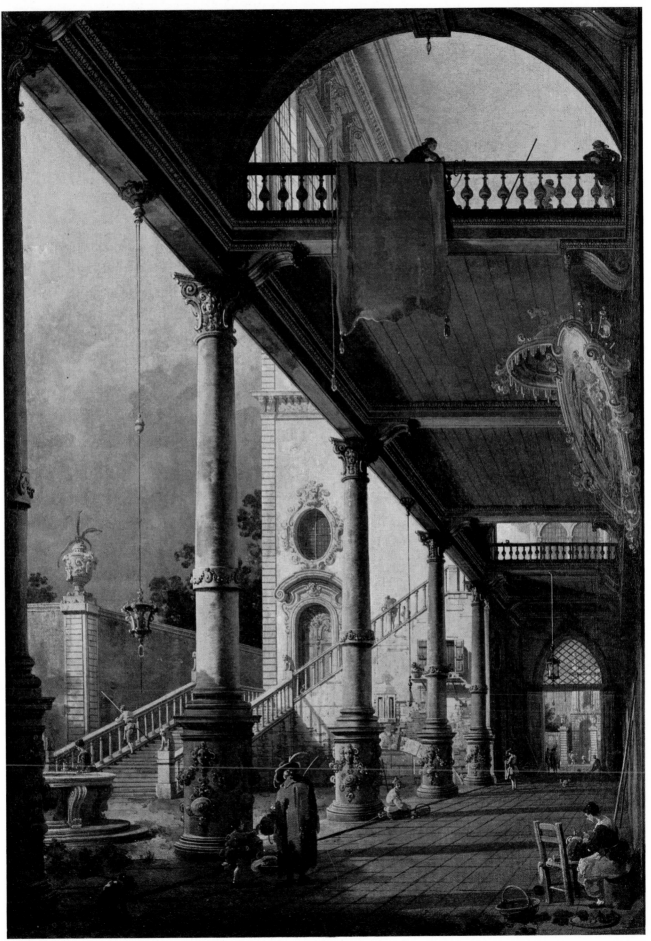

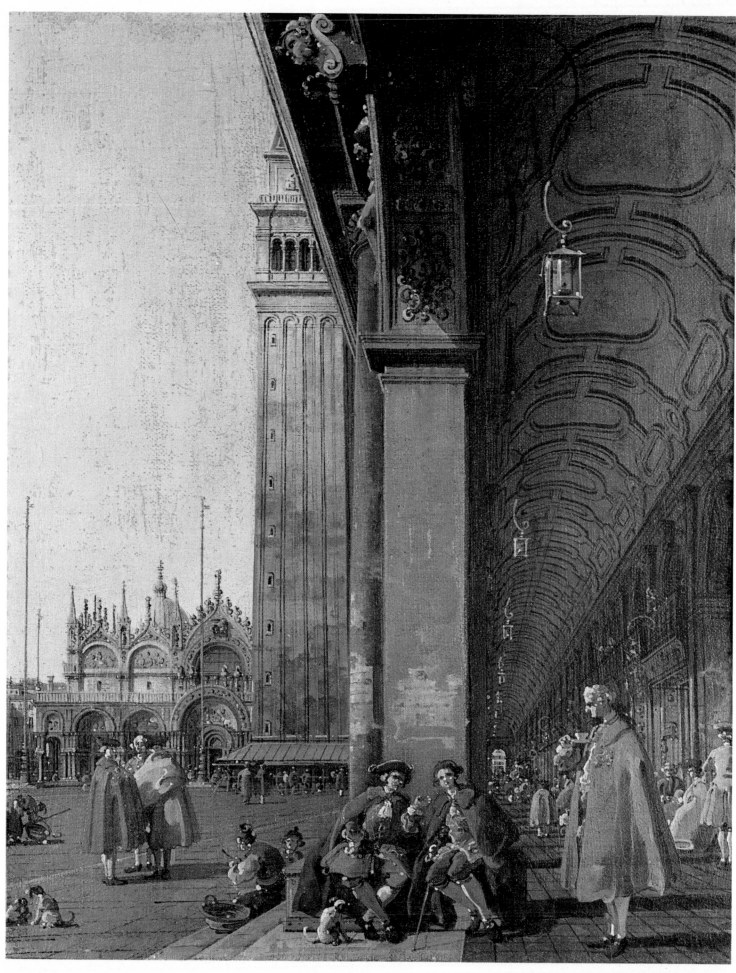

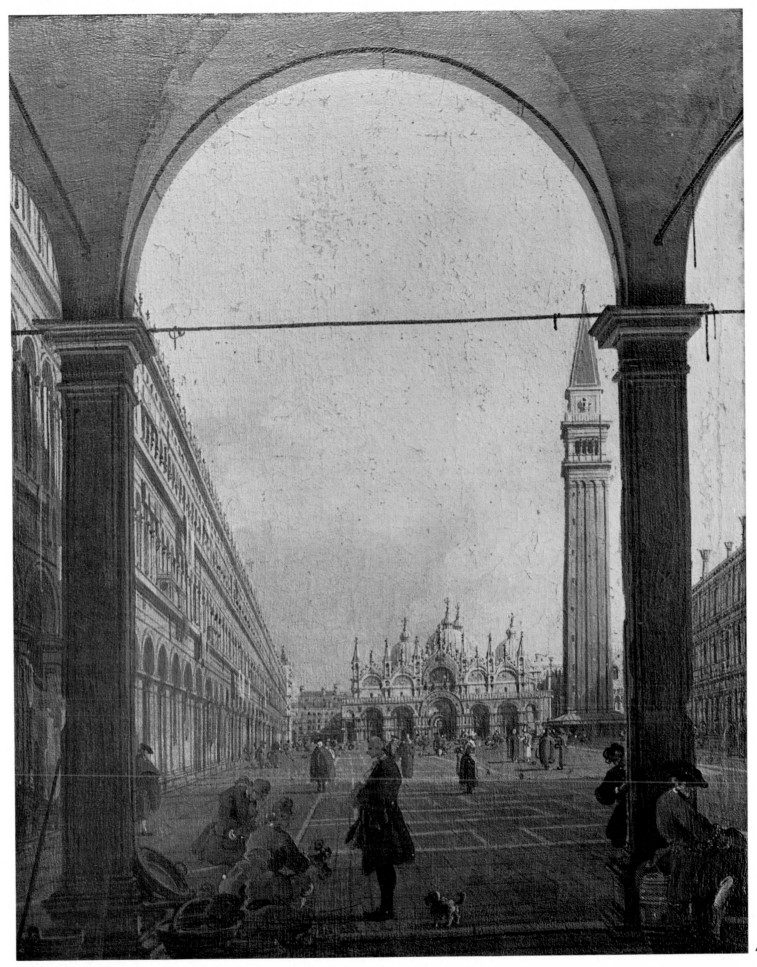

48

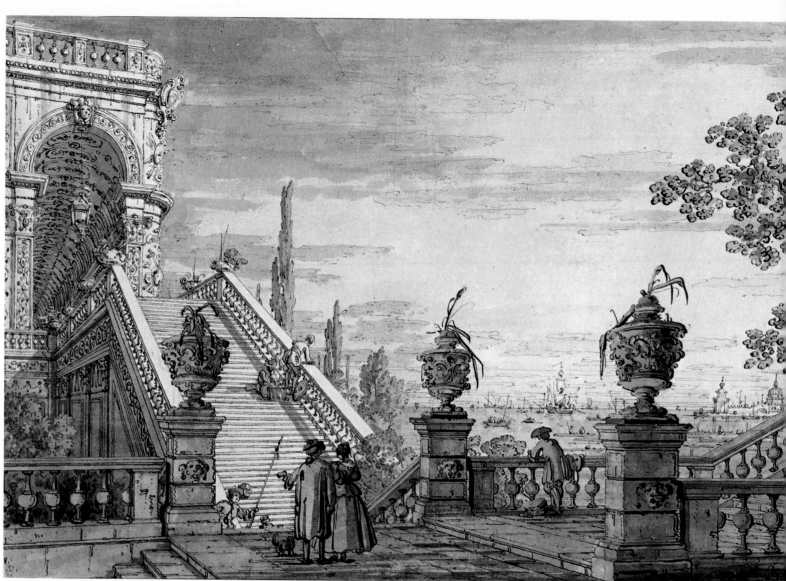

49